Insider Art

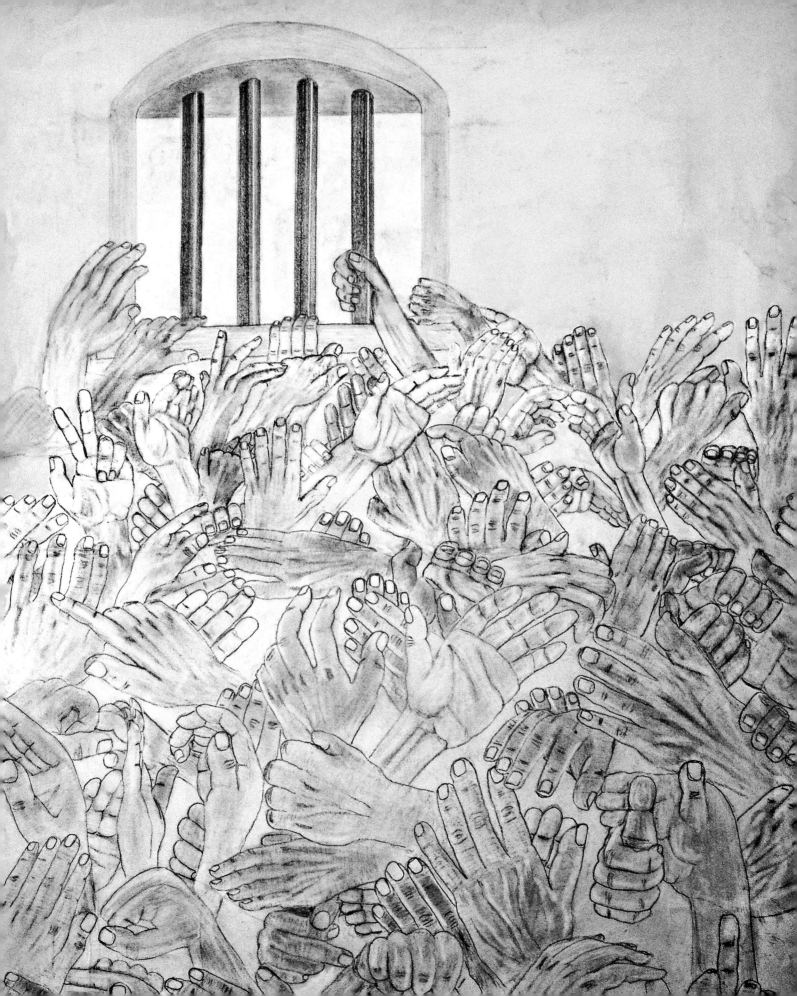

Insider Art

MATTHEW MEADOWS

FOREWORD BY
Grayson Perry

A&C Black • London

First published 2010 in Great Britain by
A&C Black Publishers
36 Soho Square
London W1D 3QY
www.acblack.com

ISBN 978-1-4081-0266-4

Book designed by Penny Mills
Cover design by Sutchinda Rangsi Thompson
Project editor: Alison Stace

Printed and bound in China.

This book is produced using paper that is made from
wood grown in managed, sustainable forests. It is
natural, renewable and recyclable. The logging and
manufacturing processes conform to the environmental
regulations of the country of origin.

Frontispiece image: Curtis Elton, *Hands*.
Right: Curtis Elton, *Downtrodden* (detail).
Cover: Paul Higgins, *Self-portrait*, acrylic.

Contents

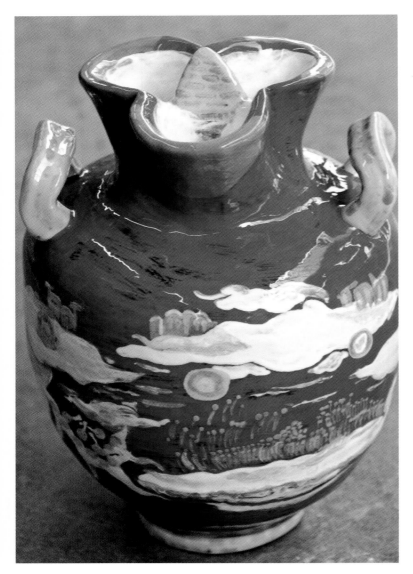 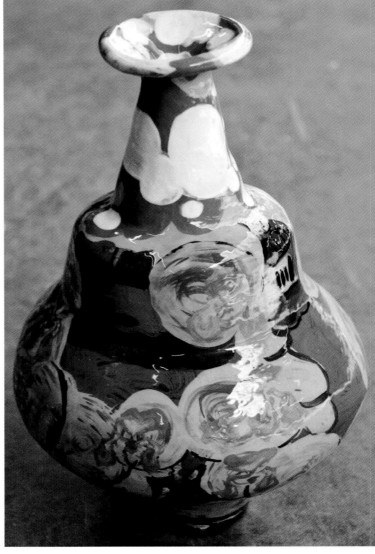

Tyrone Brouder made these two pots in the art and craft workshop at HMP Parkhurst on the Isle of Wight. He says "I'm going to always do art cos I love doing it. Its much better than doing drugs, 100 times better and there's no bad come down. Plus it gives me a natural high. I tend to meditate when I'm doing art, sometimes drifting off in thought, working without thinking in any way. It's like going into overdrive. That's probably what its like for artists with natural gifts. I think everyone has some sort of artist in them. But the real gift is loving the art and getting joy from it. Even better, someone else getting joy from my art. That truly makes me happy."

Acknowledgements

I want to thank the many prisoner and ex-prisoner artists I visited and corresponded with whilst researching this book. Those still serving sentences are detained in various custodial settings across the UK's criminal justice system: prisons, special hospitals, mental health secure units and immigration retrieval centres. All my respondents were courteous and helpful, and keen for others to see and know about their art. Various restrictions prevented me from visiting many others whose work equally deserves a wider audience: time (for example, lengthy security clearance procedures for highest security prisons) and resources, but also Kafkaesque obfuscation – the head of Decency and Commissioning at a London women's prison refused access because 'essentially, there is insufficient evidence to support our aim for all research/ work to directly support the women and/or the establishment.' But apart from the odd point-blank refusal, prison staff were also welcoming (though not always to my camera) and I am grateful to those relevant Heads of Learning and Skills, Education Managers and most of all, the prison art tutors without whose commitment and encouragement much of this work would not exist; particularly Tunde Akiniranye, David Collins, Matthew Cort, Ivor Jeffers and Jackie Newell.

Thanks to its Director Tim Robertson, this book has been sponsored by the Koestler Trust, the UK's best-known prison arts charity. I am very grateful for this, as well as for the Trust's expertise, office support and access to their unrivalled archive of art by prisoners and detainees. The kudos associated with their name and awards scheme across the criminal justice system has helped open doors. Thanks too to the Anne Peaker Centre, the national umbrella association supporting arts in criminal justice, who helped promote my research.

Particular thanks to the Arts Council of England (and my monitoring officer Sabine Unamun) who provided generous support for my research, in the belief that this art and its artists deserves a much wider audience.

Linda Lambert, my Editor at A & C Black, encouraged me, becoming herself a passionate advocate for prison art and artists. Finally, personal thanks for the support and enthusiasm of friends, particularly Jonathan Bloom, Sarah Butterworth, Kim Evans, Simon Henson, Matt Hilton, Lily Pizzichini, Dean Stalham and Robert Young. Most of all to my wife Susan, also selfishly writing books…

Foreword
by Grayson Perry

What I see when I look at the artwork of prisoners is a glimpse of the core spirit of art. What I see is the basic human desire to make something tangible out of thoughts and feelings. This spirit resides at the centre of my practice as an artist and at the centre of every art practice professional and amateur. What is particular about the work by prisoners shown and discussed in Matthew Meadows's book is that this core spirit, this well of art is somehow nearer the surface. This art is not cloaked in the intellectual fashions of high culture or swathed in hip references to art history. These works are to me, as a longtime naturalised citizen of the 'art world', a reminder of where I come from. There were points in my own youth where my life could have taken a darker turn but I chose a life in art and have never regretted it. Matthew Meadows takes us on an up-close and personal tour of the collective psyche of the inmates of British Prisons and secure hospitals. Men and women for whom art is metaphorically an escape and sometimes is literally, a life-saver.

I have long had an interest in so-called 'Outsider Art'. This is the most common term for art made away from the influence of established visual culture usually by artists who have not been to art school. In 1979 when I myself was at art college I saw the exhibition *Outsiders* at the Hayward gallery and was entranced by the work of artists such as Adolf Wolfli and Henry Darger. So when the Koestler Trust asked me to help curate its annual show in 2007, on the occasion it was staged at the Institute of Contemporary Art, I did not hesitate to become involved. Entering the Trust's headquarters outside Wormwood Scrubs and wandering round the rooms stacked floor to ceiling with thousand upon thousands of artworks submitted by prisoners is a powerful experience. What first struck me, along with the expected depictions of the brutality and boredom of prison life, were the recurring themes. Themes perhaps close to the hearts of people from sections of society that are under-represented in the visual art world. Beloved families, hometowns, landscapes are

tenderly rendered into cell wall talismans. Tigers and Eagles leap for freedom by the dozen, lascivious women lure men into trouble from all angles, coveted cars and motorcycles are worshipped in fanatical detail on every wall. I could feel immediately that this art was an unfiltered outpouring always authentic, often touching, sometimes disturbing.

We all suffer from time to time from a lack of controlling our impulses, for most of us the worst outcome is a hangover or a need to apologise in the morning. In this book are the visions, yearnings and cries of people who have not been able to deal with the deprivations and temptations life has delivered or offered to them. Lack of control may have got them into trouble in the outside world but in the world of art it is often a strong asset. Given a pen or a brush many of them find they have an ability to control a little bit of their chaotic universe. The hope is that they might take this feeling and apply it to the wider challenges of life outside.

John Carey, in his 2005 book *What Good are the Arts?*, came to the conclusion that the only demonstrable good that art does is for those who make it, particularly long-term prisoners and those suffering from depression. Though prison art is traded both inside and outside of gaol, the principle benefit of making art is not financial gain but improved mental health. Making art is no mere distraction though it may usefully make the time pass quicker. Making art is perhaps working out who you are, what you want and how you relate to the world. To the sensitive eyes of the contemporary art lover, prison art can often seem mawkish, earnest and kitsch. I see these qualities as evidence that making art is a great help to these people. They are expressing heartfelt messages unselfconsciously to the world, to their fellow prisoners and perhaps most importantly of all to themselves. In putting something non-verbal on paper we often find out and reflect on what is happening, literally beyond words, in our heads.

What I hope this timely and fascinating book does is to take the reader beyond the lurid interest in art by society's outcasts, to discovering the hugely positive role art plays in prison life and the great work done by dedicated facilitators within Britain's gaols. I also hope they join me in celebrating some of the individual talents such as Clyde Thomas, Sebastian Wilbur or David Chartens, artists who surely deserve a wider audience. This is an important book for it puts forward a powerful case for a more compassionate prison system without passing judgement; it just says look, these people have made mistakes but they have made beautiful art as well.

Wolfie's cell.

Introduction

I'm an artist, and it's a passion which burns with me to the point that it hurts. I am self-taught through books and many a long night and a short pencil.

This intense and melodramatic sentence is spoken by an inmate at HMP Wealstun. He and hundreds of other inmates in penal institutions across the UK have made art from troubled lives and imprisonment.

This book describes some of the ways in which art is being made now in custodial settings across the UK. In 2009 there were 90,000 men and women in custody, on remand, sentenced or detained, including 3,000 young people. They are held in 139 prisons, as well as many other kinds of 'closed' establishments: young offenders institutions, immigration retrieval centres, high security special hospitals and other secure mental health units. Why is there a growing audience for art made by men and women who became artists whilst imprisoned, and why are we interested in their work? Perhaps the risk taking and rule breaking which put some of them inside find expression in their art, and we respond to its conviction, originality and often compelling content. These are also creative qualities associated with some of today's most innovative contemporary artists, and many of these find an affinity with this work. Some, like Jeremy Deller, have sought to challenge barriers of artistic inclusion by placing work like prison art into a wider, more popular context accessible to both the gallery-going and general public. But as well as the professional artistic community and its audience, the artwork in this book and the circumstances of its production will be of interest to those working in the criminal justice system, offenders and their families.

In the USA prison art has established a market for itself, served by galleries and websites, and prisoners not uncommonly sell work directly to collectors from their cells.[1] If not in the mainstream of contemporary art, it has found a natural place amongst the sub-genres of American folk and outsider art. Aficionados of untutored art forms in Europe have also provided a platform for 'insider art', and plans are afoot in Holland to establish a permanent collection of European prison art in a disused prison building. [2]

In the UK, the widening audience for prison art is largely due to the work of prison arts charities, primarily The Koestler Trust, the biggest of these. The Trust was founded in 1962 by the writer and thinker Arthur Koestler, who had himself been imprisoned three times: by Franco's forces during the Spanish Civil War, subsequently by the French at the Le Vernet Detention Camp, and when he finally came to England as a refugee he was detained once more in HMP Pentonville as a foreign national. Recognising its transformative virtue, Arthur Koestler set out to reward creative achievement by inmates with cash prizes, and from its inception the Trust has organised an Awards scheme for art by prisoners held in UK penal institutions', as well as exhibiting and selling their work. Its scope has expanded steadily, and it now receives work from over 6,000 entrants covering 49 different art forms each year. Offenders supervised by the Probation Service as well as UK citizens imprisoned abroad are also eligible for entry, as are recently released ex-prisoners. The Award scheme enjoys considerable prestige amongst entering institutions, who take pride in successful entries, and entrants themselves provide numerous testimonials describing the sense of recognition and achievement a Koestler Award has given them. The Trust gives 10% of all sales to Victim Support, the UK charity which helps people affected by crime.

And what do victims of crime think of prison art? According to Kelly Flyn of Victim Support responses vary considerably:

Victims' views are extremely diverse and range from lifelong anger to total disinterest and feelings are likely to change over time. Therefore it's just not possible to be able to say what victims might or might not think of prisoners' art – there would be those who'd think it outrageous that prisons provide art courses, those who have no view one way or another, and those who'd say it's a good idea.

Accordingly Kelly Flyn suggests that victims' feelings about prison art reflect society's varying attitudes (and changing government policies) concerning the purpose of imprisonment, ranging from rehabilitation to punishment, and some, both victims of crime and public at large, will remain unhappy that prisoners should benefit from imprisonment by exhibiting and selling their artwork. Should any serving inmate be seen to profit or benefit from art made inside? The premise of this book is simply that the quality of the artwork demonstrates the value of the artists' creativity, irrespective of the crimes they have committed.

But for many there are crimes which place the artists who committed them beyond reparation. Early in 2009 the maker of a popular and previously anonymous piece of prison art which had recently been exhibited in London[3] was unmasked as both child murderer and sex-offender, serving a life sentence. Shortly afterwards an appeal lodged on his behalf succeeded in reducing his original sentence – a minimum of 30 years – by two years, and his creative activities were used in evidence of his

rehabilitation. The families of his victims were outraged by this and were further upset that a percentage of the artwork's sale price had gone to the artist. The Royal Festival Hall issued an apology to the families for the distress caused, removing the work from display. Many supported this action (including some arts journalists in liberal broadsheets), and the journalist who had 'outed' him has declared his intention to continue to identify other sex offenders exhibiting anonymous artwork.

Today sex offenders, particularly paedophiles, are seen as monsters and treated as pariahs. In the UK – as in most countries – these crimes mark a moral boundary, and nowhere is this more sharply observed than in prison, where traditional hostility to 'nonces' is well known. Roughly 10% of the total prison population, sex offenders are sometimes integrated with other prisoners but mostly isolated in sex offenders' prisons, Vulnerable Prisoners' Units, or high security special hospitals.[4]

Several of the artists discovered and published by early 20th century psychiatrist and art historian Hans Prinzhorn were sex offenders, detained indefinitely in Swiss mental asylums: a number of these now have blue-chip status in the art market.[5] Unlike artists from a similar background today, the nature of the crimes which got them locked up continues to draw little comment, and appears to give no offence.

Art by inmates imprisoned for murder also attracts less comment or notoriety in the UK: the moral outrage required to fuel a crusade to expose 'lifer' artists seems absent, both from victims, press and general public, and their artwork is regularly exhibited in general exhibitions of prison art, albeit anonymously. In America 'Serial Killer Art', part of the wider phenomenon of 'Murderabilia', has attracted an art market with exhibitions, auctions and collectors, many of whom acquire work directly from prisoners. Controversial exhibitions have drawn protest, notably about the inclusion of artwork by serial killer Arthur Shawcross in a state-sponsored exhibition in 2001. The sensational character of Murderabilia has led several American states to ban the direct sale of artwork and other artefacts by inmates.[6]

Nearly all of the artists interviewed and featured in this book have chosen to be identified by their real names. Some chose pseudonyms, one or two wanted to remain completely anonymous. With some exceptions – the graffiti artists for example – their crimes aren't identified, though when the length of some sentence tariffs has been stated this suggests the nature of their crime, as can the identity of the establishment, and these have mostly been named. Artists and their work presented here come from the full extent of the 'offending spectrum' and a wide range of establishments across the UK's criminal justice system.

Prisoners make art in many forms. Some of these are illustrated here, the work of artists I visited in prisons and other 'closed' settings in the UK. They responded to appeals placed in prison newspapers and magazines, and I went to interview them and document their work. This

was not always possible: some of my correspondents were unexpectedly transferred, others were released, and I was unable to visit any of those who had written to me from high security 'Category A' prisons. But I have included ceramic work by some of the detainees held in these prisons under anti-terrorist legislation, thanks to the efforts of those who have represented them and exhibited their artwork, notably the solicitor Gareth Pierce and human rights organisations such as Cageprisoners.

I have also drawn on my own experiences of the criminal justice system, both as an artist working in prisons for arts trusts and community arts organisations, and as an art tutor teaching in prison art education departments. In addition I have had access to the archives of the Koestler Trust, who have generously made these available to me, as well as providing advice and expertise.

Whatever the scale of their creative ambitions and the varying circumstances of its production, for all these prisoners art has been a vital and nurturing resource. How and where do they make it? There are prisoners who have discovered creative vocations and have come to think of themselves as artists, but are less interested in qualifications and prefer to work in their cells, away from an art class in the Education Department. They get sufficient approval and acknowledgment of their creativity from family, other prisoners as well as officers on their wing or landing, and sometimes a regular income from portraits. In fact, within their

prison community they might seem to have more respect, recognition and prestige than many *bona fide* artists outside. However wider access to art education has certainly impacted on the production of cell-based art and is probably linked to a reduction in the number of approved postal suppliers favoured by prisoners for personal art or craftwork. Health and Safety directives as well as security issues have also affected materials previously permitted in cells such as oil paints, although these circumstances can vary greatly depending on the establishment. Art materials will be regarded very differently in a local prison with a high turnover of short-stay inmates on remand than in a category 'C' training prison.

Although its redemptive and rehabilitative benefits might seem self-evident, the evidence presented here suggests a complex and ambivalent picture of creative activity in the British criminal justice system. Those working in prisons such as managerial staff, art tutors and officers provide anecdotal evidence that inmates participate more effectively with sentence plans, behave less aggressively, improve self-esteem, develop their communication skills. Research both in the UK and USA supports this, and further evidence suggests recidivism rates being reduced.

And despite the challenges faced by artists, art education departments and arts organisations working in the UK's criminal justice system, few countries can match its diverse range of arts provision.

NOTES

1 Much of this work is produced in prison cells, rather than prison art classes: Phyllis Kornfeld in her book *Cellblock Visions* (Harvard, 1997) describes the era before the recent Bush presidencies as a golden time for prison art, lamenting the subsequent closing down of many educational and cultural facilities across American penitentiaries as a result of conservative policies on crime and punishment.

2 This initiative comes from a group of Dutch artists/ prison art teachers. See www.artinprisons.nl.

3 The Koestler Trust's 2008 annual Awards exhibition, held at the Royal Festival Hall, London.
It was returned to the Koestler Trust and resold elsewhere.

4 It has been suggested that because of the growth of internet-related sex offences these could form the largest single category of custodial sentences by 2020.

5 This subject is explored further in the 'Outsider Art' chapter later in the book.

6 Although the Home Office prohibits convicted inmates in closed establishments in England and Wales from running a business or receiving financial profit from any activity, an exception is made for the sales of artwork through the Koestler and Burnbake prison arts trusts. This doesn't include successful entrants in the Scottish prison estate who can receive their Awards but not their percentage of cash sales. The prisons get to keep the money.

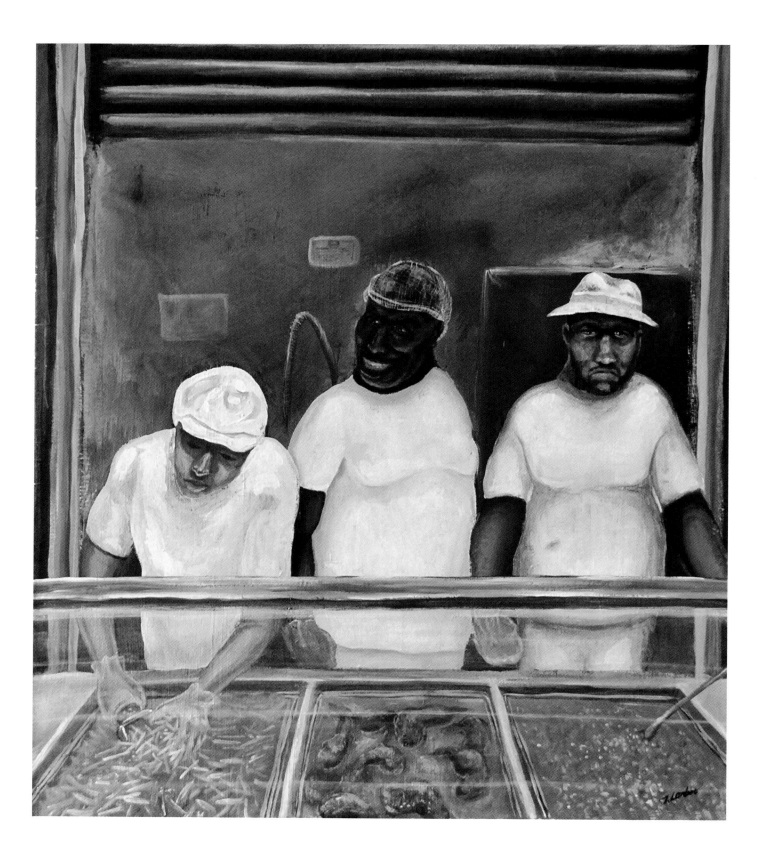

A PRISONER'S TALE

I am a lifer and was convicted in 1999 at the age of 14. I started my sentence in a secure unit and then moved on to several young offender institutes and finally the adult establishment. I enjoyed art at school but never took it seriously, it was just another class. Since coming to jail, I've found excitement in finding new ways to express myself, art has been very therapeutic to me and helped me in coming to terms with my experience. I think the young age at which I came to jail has shaped a lot of my thinking and I can see the importance in finding a passion in life. Through art I found a purpose which has helped me in living a constructive life.

I have no way of getting a copy of my work and therefore avoid selling it or trading it. I don't personally do work for other prisoners as I enjoy my freedom. A lot of people tend to want a portrait of their kids or something 'nice'. They don't want you for your ideas but for your patience and ability to meticulously copy a photo of their child. When working on this painting, I was asked a lot of the time why I was doing it. I find this understandable as many in prison see art as escapism and have a narrow view of what art can be. Sending your work off to the Koestler exhibition is a great opportunity to have your work seen outside of the art class and prison.

This painting is of the Servery – a place I have worked in and become familiar with over the years. There is a lot of drama that happens behind the Servery and there are many reasons why there is often not enough food. One of the main reasons can be seen in the tight Servery whites worn by the prisoners, slaves to their jobs, eating to avoid their unnatural hunger, like the figure on the far right.

Although they can still have a laugh as seen by the central figure. It's a running joke for the Servery to tell people to avoid certain foods on account of it being 'suspect'. This is normally to the benefit of those working in the Servery. The central figure finds this scenario amusing but those receiving the food rarely do.

The figure on the left is just getting his head down and serving the food, not fazed by the job or by circumstances. This doesn't mean to say he's any better than the others but I suppose with this painting I was trying to show the different ways in which people deal with the circumstances they are given and how this can also affect those around them.

Terence Lambert

(Koestler Award Winner)

opposite Terence Lambert, *Come Get Ya Meals*, acrylic. Courtesy of the Koestler Trust.

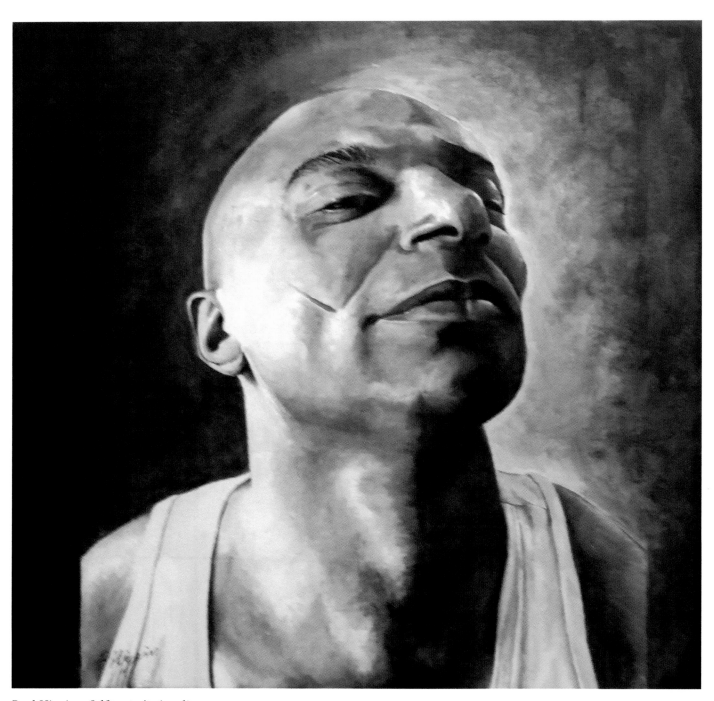

Paul Higgins, *Self-portrait*, Acrylic. Koestler Trust.

Prison Art School

Some prisoners prefer to work in their cells, but for those who want access to more resources, training and qualifications, an art class in the Education Department is the place to go. What will they find there? Most of us remember the art room as a refuge from conformity: a place for self-expression, with less pressure and a more adult and sympathetic atmosphere, and the art teacher granted a more relaxed role. This relative freedom is particularly precious for prisoners.

But for many, their last contact with education may well have been difficult, and for these prisoners, memories of underachievement are overcome more easily in the art room, helping reconcile the prison student to the class environment. Sue Saxton, Head of Learning and Skills at HMPYOI Bullwood Hall recently emphasised the particular value of art programmes for offenders:

I think it is very important to have arts in prison and I think it's important because art works: it acts as a gateway for people who haven't necessarily been successful in learning before to come into education or some sort of learning activity. Once you've got them in the business of learning and seeing they can succeed, then we've opened a door and given ourselves an opportunity to engage with them.[1]

Research supporting the effectiveness of this route to education, i.e. prison students' progression from art class to further subject areas, is still forthcoming. But even if presently anecdotal, it is clear that this is the index for measuring the value of creativity in custodial settings most influential with policy-makers – it's gateway value – though prisoners themselves are unlikely to justify their attendance at art classes in these terms.

Another issue is the lower rate of pay prisoners may receive for going to education classes rather than industrial skills training courses, prison work details or outside business contract workshops. This can prejudice entry to art classes in favour of younger first-time offenders or remand prisoners; these are more likely to receive financial support from outside than older prisoners[2], thus effectively subsidising their attendance.

Teaching art in local prisons can be particularly challenging for the art tutor. These

are usually older, inner-city prisons with a volatile and transient population including young inmates on remand, those serving short sentences and others waiting to be allocated to other prisons where they will serve a longer sentence. Daily routines are often disrupted: more frequent legal and family visits (which may well tail off all together after sentencing) compound the emotional stress of a first time inside, particularly coming up to court day. The environment in detention and immigration removal centres is similar, and for all these inmates, life inside is even more unpredictable than in other parts of the prison estate.

So short-stay students will be lucky to find a stable, peaceful place to do art. Some of the young men or women in the art room may not be interested in education, and prefer to spend most of their time chatting to their friends in the toilets. Others attend the art class just to kill time. In these circumstances, art tutors may well prefer a stricter regime and given students' inexperience and unpredictable length of stay, hope to take them through entry-level qualifications. David, art coordinator in a large local prison, describes the challenges he faces:

The transient environment is very difficult to teach in for various reasons: I work hard developing a relationship with students, then off they go. If they have some aptitude, I try to build into their thinking the value of continuing creative activities, even if they are released after remand. Despite the gratification of seeing people's confidence build up within 6-8 weeks, it can be incredibly demoralising not being able to connect inmates up with the next step – education or work opportunities, but this is very much the nature of working in a local prison.

QUALIFICATIONS

The prison art teacher can come under pressure from the education manager to deliver qualifications, and funding and resources can be dependent on these. The education manager may well be under pressure from the prison HOLS (Head of Learning and Skills), who in turn is under pressure from the Governor, who is driven by Key Performance Targets. The pressures of curricular coursework, unless delivered with flexibility and imagination, can dumb down artistic self-expression in favour of streamlining qualifications often dominated by 'copy art'. David thought that many prisons were heavily target-driven, but recognised that at his prison the art department got off relatively lightly in this respect, largely in recognition of the difficulties described above.

Manchester College is the largest education provider to the prison estate, contracted to deliver education to 76 of the 139 prisons on the UK mainland. Second largest is A4E, an international human resources and training company who provide education in 32 prisons. They and most of the other regional further education colleges in UK prisons accredit these courses through the 11 regions of the National Open College Network.[3]

However despite these OCN qualifications being in such widespread use for offender learning, there have been some doubts as to how effective they are in terms of the overall art and design curriculum, and they are attracting less funding. Outside their prison contracts, several of these colleges have abandoned art and design OCNs in favour of BTECs because they progress more easily to further educational specialisation, and are more attractive to employers.

At establishments housing prisoners serving longer sentences, typically training prisons, art education departments can pursue higher-level qualifications. These establishments generally have a more settled atmosphere, particularly those that hold lifers. One of these is HMP Gartree, a B category training prison. As well as OCNs, GCSEs and A-levels, its education department is now running a BTEC in Art Enterprises, allowing students to do art-based business studies as well as a digital 'e-image' course. This may give students a chance of employment in the 'creative industries' or at least provide a progressive step towards college on release.

In order to maximise the through-flow of students a prison art department may limit a student's time there to completing available courses, and he will then be expected to relinquish his place in favour of others, as is the case at HMP Swaleside. This B category training prison in the Isle of Sheppey prison cluster takes prisoners starting out on longer sentences, more than half of whom are lifers. When I met Tim

there he was 27 years old, and five years into an 18-year life tariff. He started doing art a year after his arrival, attending classes in Education. The art tutor runs NVQ courses in applied art and design: results are impressive, with consistently high grades. Students do 'client-based' projects using all sorts of processes and techniques, and the art room seemed busy and productive. When I visited I wondered whether this left less room for 'self-directed study', and one student told me quietly that course demands meant he couldn't do his own work. Tim progressed well in the art class, even becoming 'peer tutor', but was moved on after completing his course to make room for others. He now misses the range of materials and different processes previously available to him in the art room. Because he was motivated he kept painting in his cell, but many might find such dedication difficult to maintain outside the social support of the art room. Recognising this dilemma, the art tutor at HMP Springhill sets one afternoon each week aside for art students to pursue their own creative interests outside coursework. In fact projected changes in Learning and Skills Council (LSC) prison education funding will allocate 80% to core subjects, with 20% set aside for other activities including art. For these latter subjects there will be less pressure to deliver accreditation. However there is unease about this news amongst some art tutors, who are unsure about its eventual impact.

How do prison students themselves feel about accredited art courses? Anecdotal evidence from informal interviews with

students as well as tutors suggests that most of those attending classes enjoy structured, social learning and are proud of their art and design qualifications. Like most other sentenced prisoners going to Education for the first time Simon wanted to use his time productively. The prison's education orderly had told him that the only class with any vacancies available was art. Simon wasn't at all happy about this: he had no interest in art, in fact had never visited a gallery or museum before. However he was persuaded to take part in the class by the tutor. Simon found the entry-level LOCN exercises – colour, shade, texture and so on – very useful, though he was less interested in art history. He quickly gained confidence and something of a reputation on his wing, and was soon doing portrait commissions for tobacco, working from snapshots of girl-friends and inmates' children. A non-smoker, he traded this for other things in the canteen. Perhaps as a result of attending offender behaviour programmes Simon seemed at ease with the language of personal development:

Part of why I'm here is that I was so isolated. Art is a healthy pastime – it will help me socialise, develop life skills, achieve things. I've realised that a major problem I've had in the past was low self-esteem. The answer is to set goals, and achieve them. Gaining prison art awards has helped me do this, also getting qualifications such as OCNs, then GCSE and AS level.

Like many others who have found a creative vocation in custody, he is determined that art should remain an important part of his life when he is released.

Prison education departments are different from school or college, and not even the temporary oasis an art room provides can escape the pressures of conformity and control, which pervade any establishment. As elsewhere the constant requirements of security are always present. These rules vary greatly from one establishment to another, and their severity is not necessarily related to the prison's security category. Some prison education departments keep classrooms locked during classes, others do not. One may allow full sets of lino-cutting tools on the 'shadow-board'[4], another ban them completely. In one establishment the art room shadow-board will only be open for students' use of scissors, compasses and other often vital tools if all present have had sufficient security clearance, in other words no mention of use of knives or other dangerous weapons on their charge sheet. Another same category prison makes no such restrictions, and prisons with previously higher security categories can retain these responses even after they have been downgraded. Oil paints may be allowed in some establishments, not in others, apparently for health and safety reasons. Sometimes long-stay inmates might get to use them in their cells. Wing officers rewarding compliant behaviour (as distinct from the official IEP scheme[5]) may dispense such privileges on a more informal basis. Some prisons won't allow portrait drawing or painting in the art room on security grounds:

a sex offenders' prison for example may be particularly sensitive about identifying inmates. This irony persists despite the many daily portrait commissions inmate artists carry out on wing landings up and down the country – often for officers and their families. In one prison, however, landing officers took exception to the practice of portrait commissions. Here a prisoner now painting full-time in his cell recounts his own experience of their attitudes.

I gave them (portrait commissions) up. There is too big a demand for family and girlfriend portraits – if you start, there's not enough time to do your own work. Anyway on my wing the officers don't like it, they see it as running a business, and they said there's a security issue about recognisable likenesses. The art orderly was kicked off my wing for doing commissions: Best keep your head down, or they make you laugh a bit harder.

The references to 'too big a demand' and 'running a business' suggests that on this particular wing – for unknown reasons – the officers thought the practice was getting out of hand. It is worth noting though that on another wing in the same prison officers were employing a prisoner as official prison artist, providing him with materials and a variety of commissions.[6]

Other more general conditions controlling art activities depend largely on the predilection of both the prison Governor[7] and head of security. Because of their career structure prison Governors come and go, and incomers keen to maximise their Key Performance Targets may well want to change how inmates should best engage in 'purposeful activity' – the minimum 24 hours a week they are meant to spend out of their cell. In addition to education classes, prisoners may do industrial work and training, as well undertaking offending behaviour programmes. For example, a Category B local prison with a thriving ceramics department and music group had both its kiln and musical instrument collection mothballed by an incoming governor. Two governors later, a building programme and expansion of the education department has seen their use revived along with concomitant accredited courses.

The role of security governor on the other hand will be rotated amongst the establishment's own security officers. They will know and share the prison's culture much better, indeed have helped shape it, implementing its local and idiosyncratic do's and don'ts. A sympathetic and experienced officer on the wing may be flexible in the observance of these, particularly one who has seen the benefits a creative hobby can bring a prisoner.

Martin

Martin is at HMP Littlehey, nearly halfway through a five-year tariff. He left school at 14 to serve an apprenticeship in the building trade. He went to Borstal when 17, but hasn't been inside since then. He has kept himself busy in prison. Drawing in his cell – his father was always drawing at home – led to joining art classes in Education for two to three sessions a week, but he has continued to work on his own. He has developed a painstaking academic style, working in oils, often making copies of old masters. Vermeer's *Girl with A Pearl Earring* is a favourite.

I keep a record of my paintings, so that I know where I am and can see how I improve. If I don't know where I am, I ask a couple of people and they put me right. As for my paintings, they don't take me very long – 2¹/₂ weeks at most.

His brother or mother takes these out on visits, mostly to his mother's home in Stevenage. Over the past year he has completed several portraits of Stevenage's most famous son, racing driver Lewis Hamilton. Martin said that locals still grumble about him going to live in Switzerland. Although art is something Martin has worked hard at, he has no illusions about an art career on release, and hopes to open a gym in Brighton with his brother. He is determined to carry on painting in his spare time though, and exhibit his pictures in the gym.

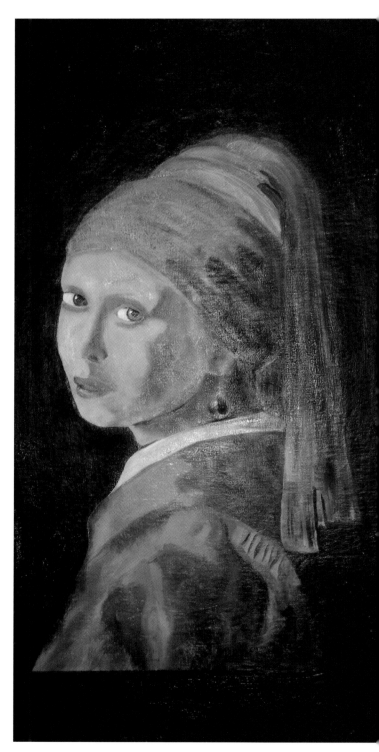

above: Martin House, Vermeer's *Girl with A Pearl Earring*, acrylic.
right: Martin House, *Lewis Hamilton 1*, acrylic.

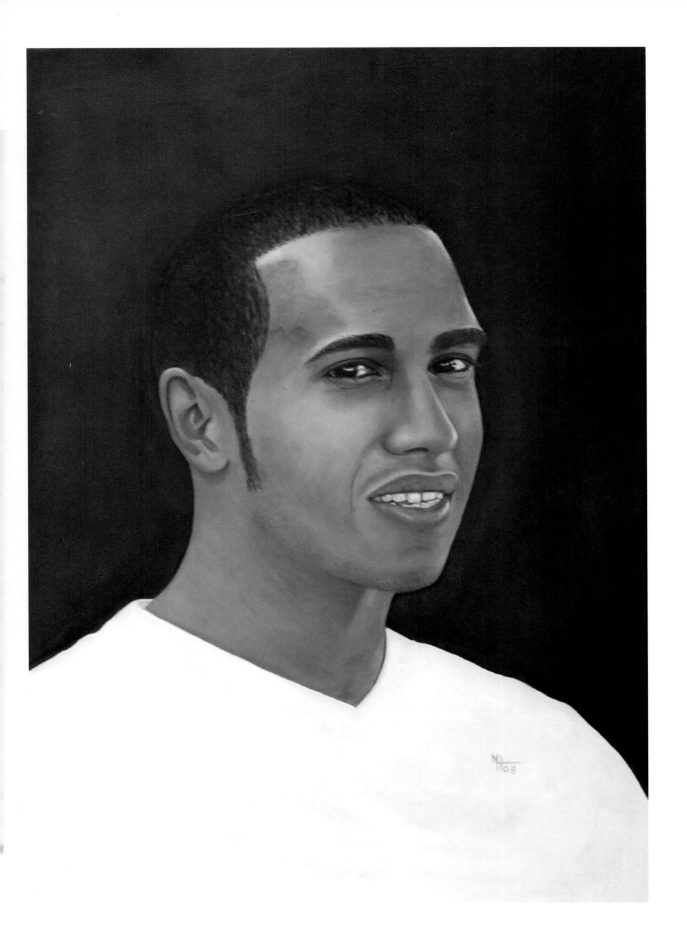

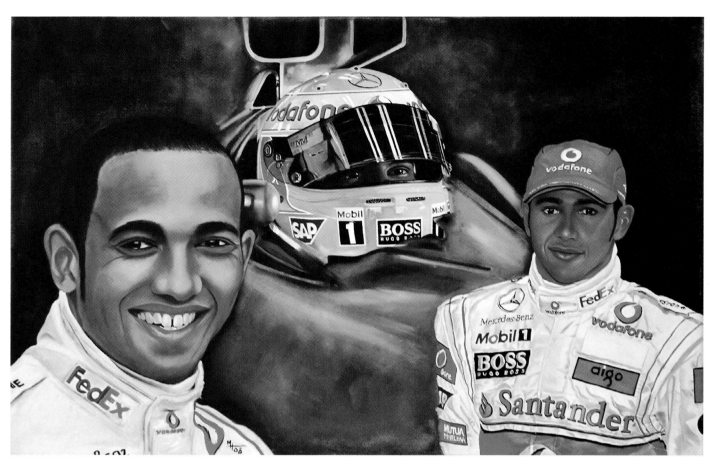

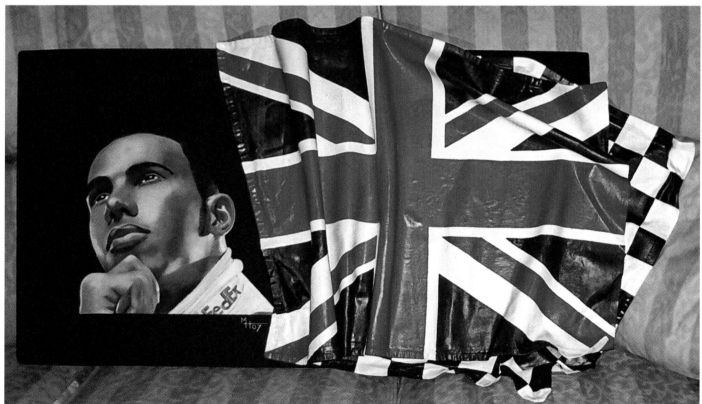

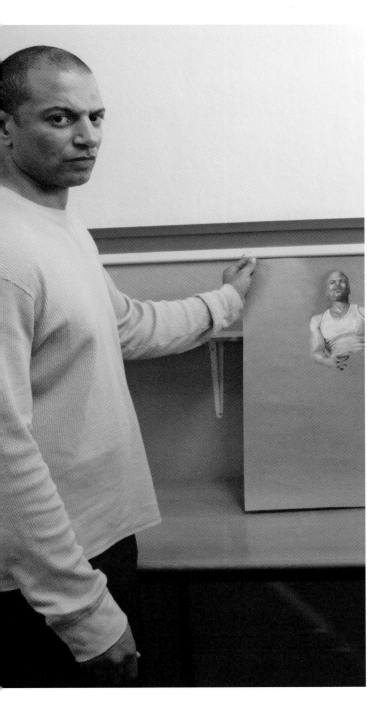

above: Paul Higgins, photo with unfinished self-portrait, acrylic.

opposite, top: Martin Housem, *Lewis Hamilton 2*, acrylic.
opposite, bottom: Martin Housem, *Lewis Hamilton 3*, acrylic.

Paul

Paul's artistic vocation was shaped exclusively through prison art classes. Now 40, he has been a career criminal most of his adult life and has been in and out of prisons for 20 years. He has always enjoyed art, and can remember when five years old making drawings of the film *Zulu* when he saw it on TV. He started doing art aged 25, whilst sentenced at Leeds prison. At this time he was content to draw or paint copies, but a little later on he went to HMP Everthorpe. Here the art class was challenging and stimulating, and he learnt about art history and contemporary art. By now he was doing art full-time in Education, as well as painting back in his cell. When I talked to Paul he was half-way through a three-year life tariff at HMP Gartree, had completed available art courses and spent every day in the art room as art orderly, assisting the tutor as well as helping other students with their coursework. Otherwise he was allowed to continue his own work. Paul's style borrows from cubism: he paints faceted, brightly coloured surfaces, but finds it hard to settle for one approach, wanting to go abstract but being constantly drawn back to the human figure.

I wanted my pictures to be more recognisable but also interesting in how figures or buildings have been rendered. I have developed this into my own style. Some, if you remove the figures, have a pleasing abstract quality of their own. I've also fought with myself and still do about whether to go with simple

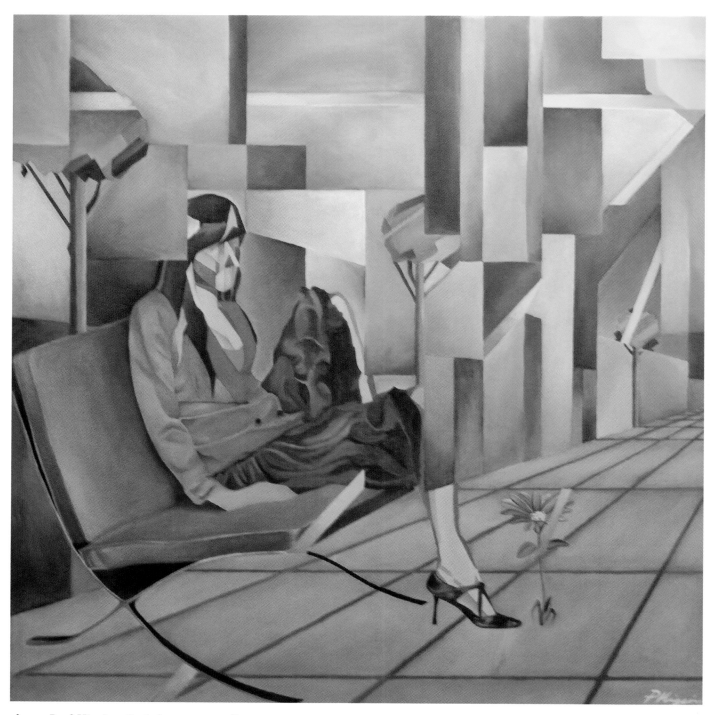

above: Paul Higgins, *Seated woman,* acrylic.
opposite: Paul Higgins, *Exploited,* acrylic.

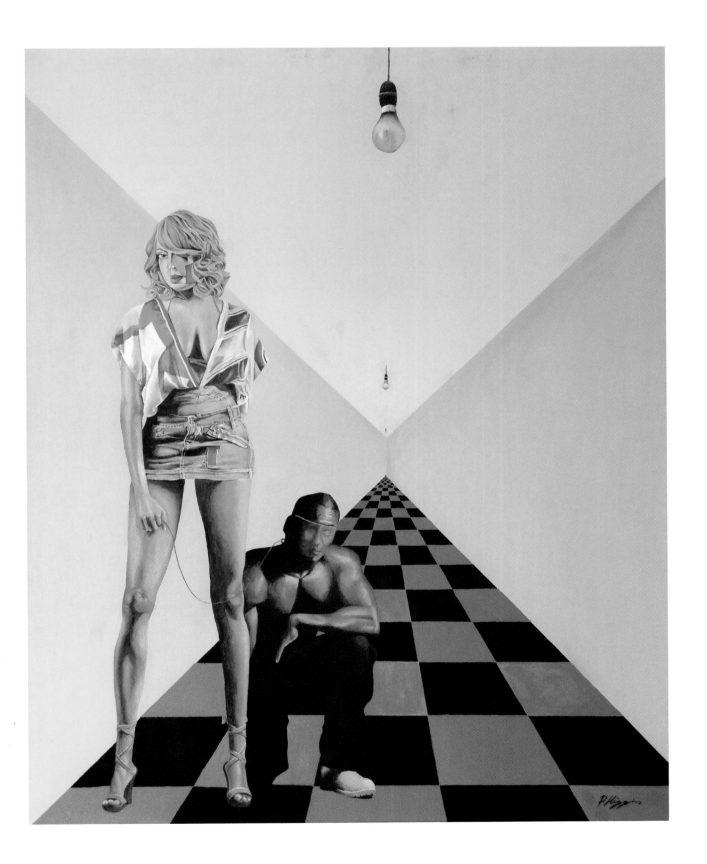

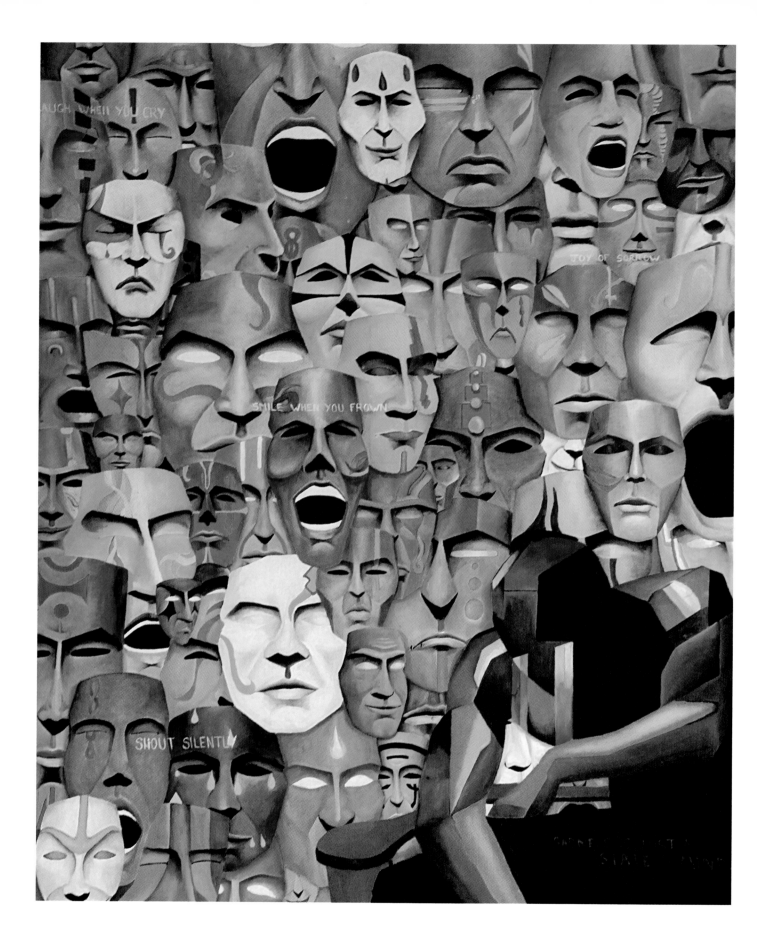

pleasing images which I know people like, or subject matter which hits on something like politics.

His pictures make oblique comments about social injustice, and he is quite dismissive about most other prisoners' ability to understand them. Paul wrestles regularly with his conflict between crowd-pleasing populism and a lonelier, more cerebral path. Perhaps he needs to oscillate between the two. He says he depicts solitary figures 'because they reflect my solitary condition'. This seems more of a reference to his estranged partner and family on the outside; segregation apart, prison could hardly be said to be a lonely place. Encouraged by exam success and prison art exhibition awards Paul has begun to wonder whether he can make a go of it as an artist when he gets out.

opposite: Paul Higgins, *Sadness is a state of mind*, acrylic.

Tim

Unlike Paul, Tim no longer has access to his prison art class; after finishing his accredited course he had to make way for others, and four years later, now works in the prison's decorating crew. He was painting a dark turquoise gloss dado along a prison corridor wall when we met. Judging by its out-of-date colour and head-spinning fumes the prisoners seemed to be using the sort of paint whose high VOCs[8] would bar it from high street shops nowadays. Perhaps it was just old stock – ironic, given that the prison's health and safety rules now prevented Tim from using oil paints in his cell. He had switched to Winsor and Newton Alkyd paints; they mix with linseed oil or water, which means that brushes can be cleaned with soap. He said they have the benefits of oil – what Tim called its 'playability', depth and consistency – with the convenience of acrylics.

Despite his day job he painted whenever he could, 'though I try not to do too many portraits in the evenings, the colours go wrong under the cell lighting'. Commissions have kept him very busy inside, though he is now down to one or two a month. He told me he has sold many, mostly portraits, to prison staff: both officers and even a governor or two, he hinted. The money is sent out to his family because it's a bit 'complicated' paying it into his prison account.

'Normally I've got several going at the same time. I'm nervous when I start out, but you always learn something, you improve on them.' He charged anything from £25 for a pencil portrait and upwards. 'It depends on who it is,

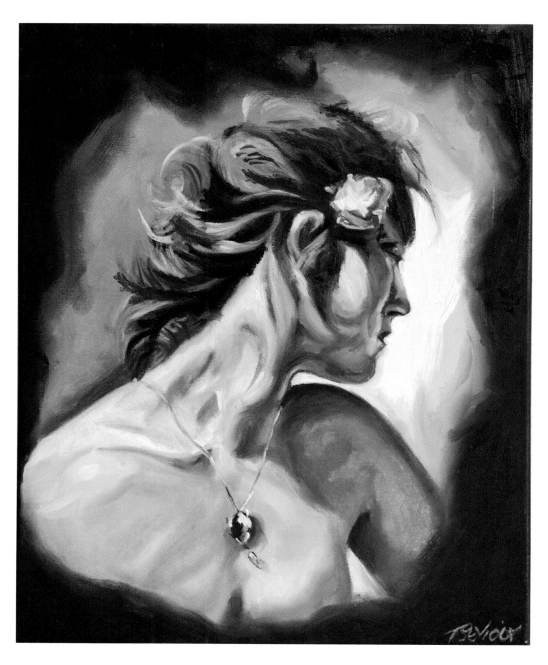

whether I like them and what they can afford. Then if it's friends or family I'd do it for free.'

Much of his work now he sends out to a friend. Many of Tim's paintings have been copies, often on demand, but increasingly he is turning to other sources: one painting showing an embracing girl

couple in hot jungle greens has a fresher and more poignant feel, classic locker-room erotica.

above: Tim Seviour, *My Girl*, alkyd.
opposite: Tim Seviour, *Beautiful Losers* (after Jack Vettriano), alkyd.

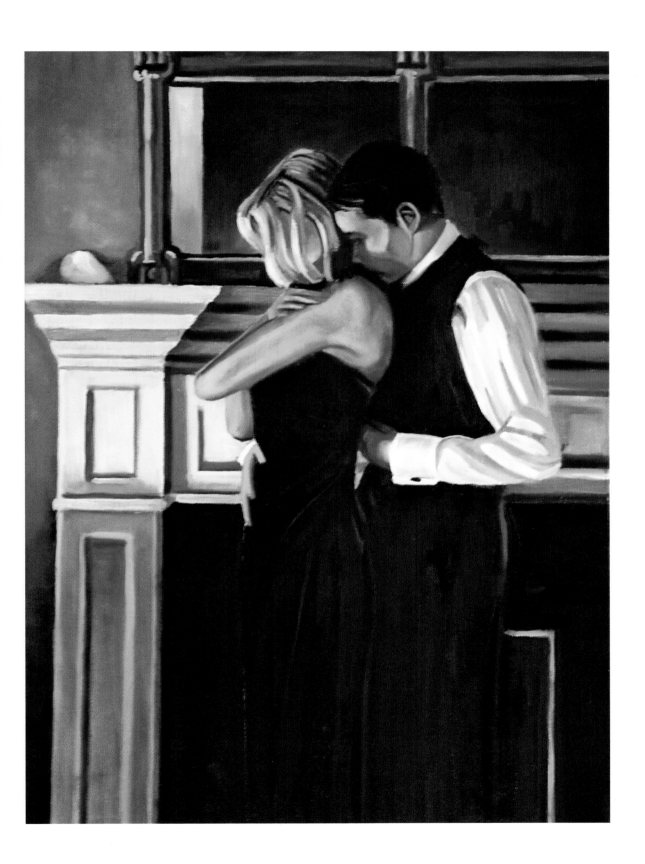

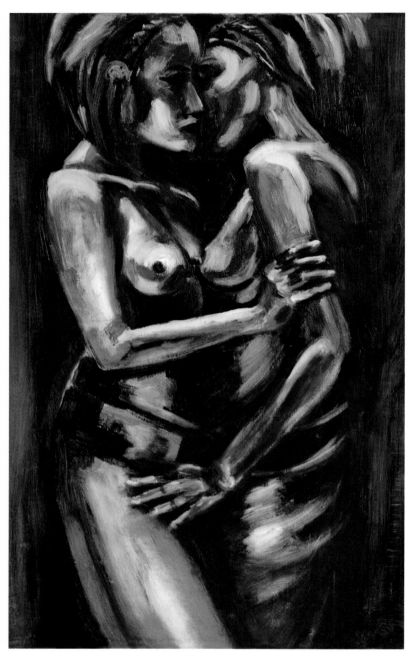

Tim Seviour, *Lovers,* Alkyd.

Tim was clear about the purpose of his art – it was escapism, not reality. 'I want to paint stuff that I wish to see, dream about. To paint something about prison defeats the object, why depict something you're trying to escape from.' So he has no time for those who do what he calls 'prison art'. He included pictures, poems and any kind of writing in this category. This hostility to prison art using the experience of incarceration as its subject is not uncommon amongst artists in custody. Although their circumstances are hardly analogous, similar attitudes were found amongst artists incarcerated in Nazi concentration camps:

What does seem unusual at first glance is the large number of works that are absolutely unrelated to the Holocaust. Still lives, landscapes, abstracts and compositions bearing little relation to the circumstances would not seem to be the subjects that were foremost in the minds of the Holocaust artists, but many such works have been found. (The Art of The Holocaust, *Janet Blatter & Sybil Milton, Macmillan, 1982*).

Tim was recovering from testicular cancer when I interviewed him: fortunately it had been treated in time. With more than ten years still to serve, a brush with death just passed, he had decided that art's absorbing and self-forgetting challenges could most help him do his time.

LATE STARTERS

As with society at large the prison population is ageing. Prisoners aged over 60 are the fastest growing age group in prison,[9] and this demographic is reflected in art classes. Creative work by those who have taken up art later in life has a distinctive character, and lack of skill or dexterity is more than compensated for by experience and conviction.

Clyde Thomas was in his 70s and serving time in HMP Wormwood Scrubs. Terminally ill with cancer, he stayed in Healthcare, but came down to art classes on Education. New to art, he made pictures from memories of his native Trinidad, using a high, map-like viewpoint which distinguishes all carefully layered features clearly. Naïve in style, their confident and diagrammatic depictions of buildings and plants seem

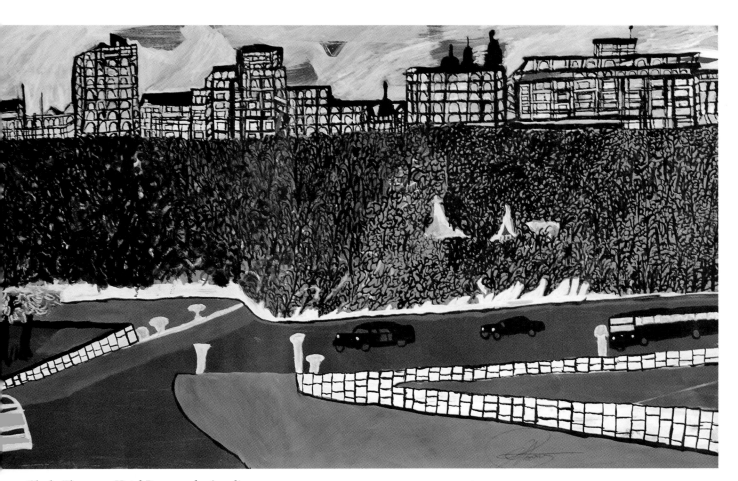

Clyde Thomas, *Hotel Promenade*, Acrylic.

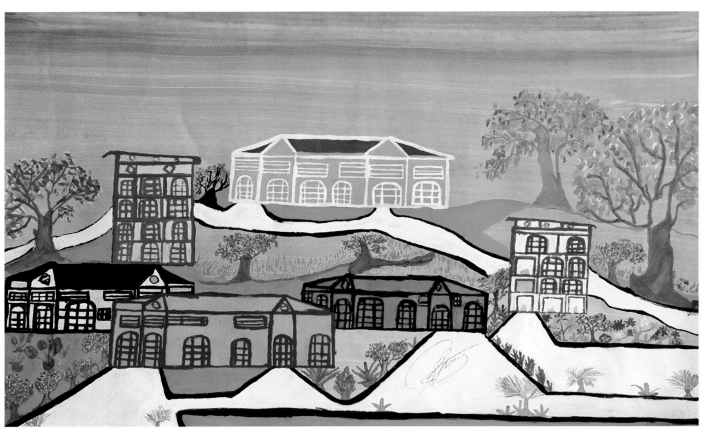

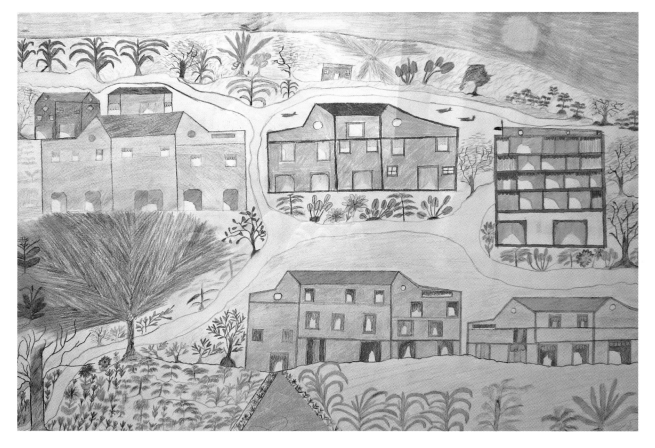

unarguably authentic – if strangely unpopulated. Clyde wasn't expected to last the year, but one day he was suddenly repatriated back to Trinidad.

Two older prisoners who started doing art in Manchester Prison's art class have both found a distinctive vision, one which takes them far beyond the prison's perimeter wall. Like Clyde Thomas, they were both new to art. They have no interest in addressing conventional prison themes, which often seem of more concern to younger inmates.

Gordon Finlay is a 70-year-old man serving a long sentence: he says 'my artwork is really important to me – I can "escape" to a different place while I am working'. Denis Hudson echoes this: 'Via the mind's eye I can travel anywhere; there are no restraints, walls or bars.'

Gordon makes his miniature landscapes with water-soluble pencils, using them like paint. Although his rural scenes echo pastoral artists such as Samuel Palmer (art teacher Marion had shown him his work), their intense colour seems too tropical for England; Gordon himself

opposite page above: Clyde Thomas, *Somewhere in Trinidad,* coloured pencils. Image courtesy of Michelle Johnson
below: Clyde Thomas, *Ocean Drive,* acrylic.

this page left: Gordon Finlay, *Landscape 1,* water-soluble pencils.
above: Gordon Finlay, *Landscape 2,* water-soluble pencils.

Gordon Finlay, *Landscape 3*, Water-soluble pencils.

mentioned Gauguin's 'richness of colour' when he wrote to me from Manchester Prison:

I had never done any artwork, never even had a coloured pencil until I joined the art class in 2007. Initially I had no confidence and was reluctant to use anything other than pencil. Eventually my art teacher 'bullied' me into using colour!! As I was reluctant and anxious about using colour, she introduced me to water soluble pencil crayons and showed me how to layer. My first attempts were images from Gauguin, making use of his richness of colour.

As my confidence grew, I became more and more interested and involved in my artwork. I was able to experiment with materials, blending water-soluble crayons with water to achieve the effect of paint. I am grateful to Marion for the help and encouragement she has given me.

Denis Hudson also started doing art at Marion's art class:

I started pencil drawing on the art class about three years ago – aged 60 – and progressed to oil pastel about a year later. I had never drawn or painted anything prior to this. I'm now starting my 3rd year of an O.U. degree in Art History.

What am I trying to say in my artwork? That's easy; it's all about freedom and privacy of the mind.

Via the mind's eye I can travel anywhere; there are no restraints, walls or bars and my artwork is constructed by this means. I do not copy or reproduce other artists – I find my own environment and subject to portray the message I want to project, then let the viewer interpret it.

And in his series 'Alien Perspectives', we get to travel in Denis's mind's eye, an interplanetary journey in which the artist appears in each scene

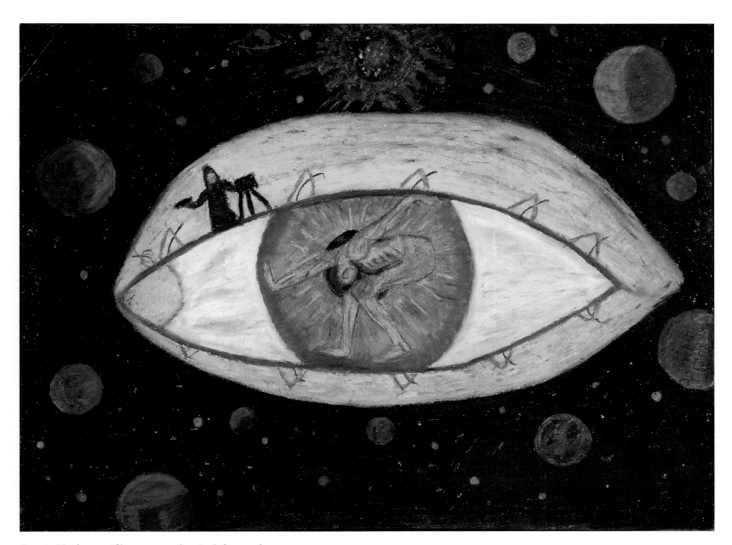

Denis Hudson, *Alien perspective 1*, Oil pastels.

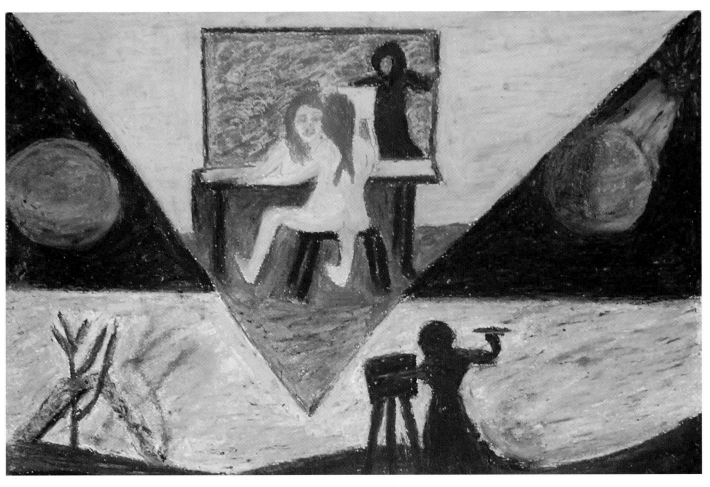

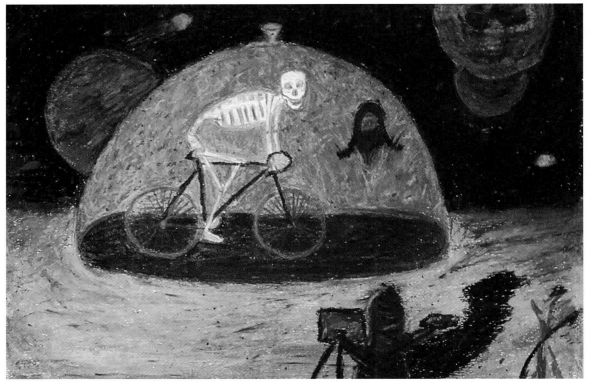

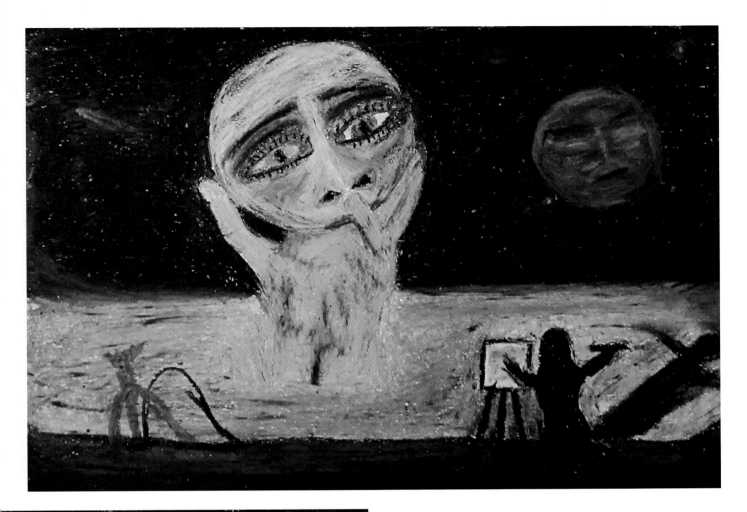

as onlooker, guide and creator. Dressed in black robes and a pointed monk-like cowl, he has set up his easel and stands before it, wielding his paintbrush. The strange scenes he summons up and projects are in turn the subject of his art.

opposite page above: Denis Hudson, *Alien perspective 2*, oil pastels.
above: Denis Hudson, *Alien perspective 3*, oil pastels.
far left: Denis Hudson, *Alien perspective 4,* oil pastels.
left: Denis Hudson, *Alien perspective 5*, oil pastels.

41

THE WOMEN'S ESTATE

There are 17 women's prisons in the UK, holding less than six per cent of its custodial population. Two are being re-roled for men to accommodate the general increase in prison numbers, despite the women's estate growing faster in size. Unlike the male prison estate in which establishments are roled according to security categories from A (top security) down to D (open conditions), the 17 prisons in the women's estate are usually mixed category. HMP Downview has a lifer's wing but also a Resettlement Unit, from which inmates go out on ROTL – release on temporary licence – to work placements or college.

Levi

One such prisoner there is Levi, who is currently serving a seven-year tariff for importing drugs. Approaching midway parole, she has been working at a prison arts charity as a volunteer. Unable to afford the plane fare, Levi became a drug mule in order to visit her daughter in London. In Guyana she had lived in a Nazarite Rastafarian[10] community where she ran a farm and school, producing illustrated teaching material for the children herself. Whilst in prison she recalled this life with sketches. Levi is uncompromising about her Rastafarian beliefs, dietary and otherwise: in prison this has been difficult, and she says she has often faced prejudice. She is not allowed to show her dreads, and wears them in a tall tower coiled above her head, wrapped in white cloth.

Levi has used her time in prison purposefully, completing a video production course in its Media Centre. She enjoys pottery, but finds art classes limiting. However the tutor lets her take materials back to her cell, where she produces her books of illustrated poems. Several women choose to stay in their cells and do craft work full-time, mostly crocheting and sewing. Only blunted needles like bodkin needles are permitted, unless inmates are trusted not to self-harm, and then they can use pointed ones. Levi intends to use the Koestler ex-offender artist mentoring scheme to help establish herself creatively, setting up a business making Rastafarian jewellery and clothing when released.

Levi Toylor-Topp, *Levi's farm*, pencil.

Sally

Sally is 57, and also served a seven-year tariff at Downview for importing drugs. She left school at 14, without any qualifications. After a series of abusive relationships with men involving drink and drugs, she described her sentence as a bonus. Like Levi, she used her time productively. She has done a computer course at Downview for the first time in her life, and spent all week in Education. She told me: 'Even if it's a small community, I've been told I'm good, and no one has ever told me that before.'

During her art class she followed course material, producing sophisticated work exploring colour and texture, also working in 3D. She also did art in her cell in the evenings. Sally's other passion was working with the Birds of Prey unit, originally set up for male lifers before Downview was re-roled for the female estate in 2001. She looked after the birds and trained them, and hoped to make a career in similar work on release. Sally has now left prison.

above: Sally, *The Manager's Office*, mixed media.
opposite page: Vicky, *Drunken Bulldog*, pastel.

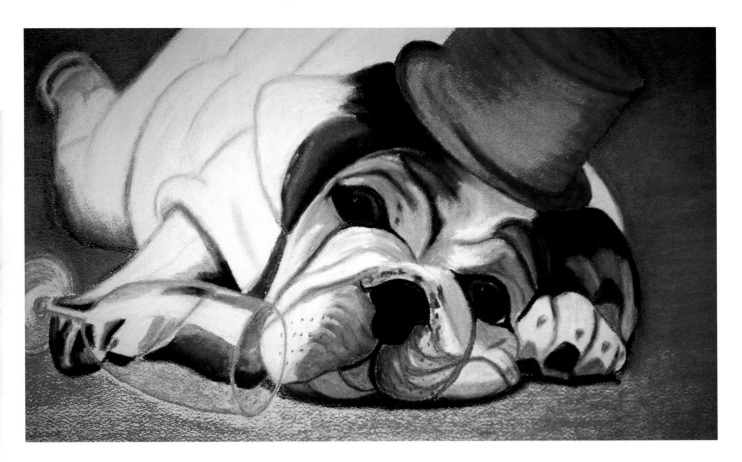

Vicky

Lifer Vicky used to share Sally's art class and they are close friends, supportive of each other's work. She does portraits and cards for others on her wing, trading these and small pottery pieces for tobacco. Vicky made her pastel drawing *Drunken Bulldog* from a Christmas card. Like Sally, prison has been a chance for her to revisit education:

I used to draw when I was little. The reason I drew is because I was in hospital a lot as a child, and all I did was draw. My art teacher in secondary school wanted me to go to art college but I left school and home at 15. The next time I did art was in 1984 when I was sentenced to prison and went to Holloway. I did an O-level in Art and I passed with a B. I did art in HMP Bronzefield at the beginning of a 12-year sentence.

Then I was sent to HMP Downview, where I went full-time in art in 2006.

Vicky's creative journey has progressed from institution to institution: hospital to school, then a sequence of prisons. Her life in between apparently had no room for art, nor was she able to use the art qualifications she had gained at Holloway. Now she does it full-time, enjoying the camaraderie of the art class:

It helps with the monotony of prison life, as you can look into your picture and you are free just for a little while in your mind. They might have my body but I am still a free spirit.

Vicky is now terminally ill.

PROFESSIONAL ARTISTS WORKING INSIDE

Another way inmates get to do art in prison is when outside artists go in for special projects. These artists work in the criminal justice system on a more or less independent basis, delivering periodic workshop programmes or one-off projects, usually as part of their wider engagement with community arts. They are unlikely to work for community arts organisations active in the criminal justice sector because most of these are theatre companies or work with other time-based or performance art forms such as dance, music or video. These areas don't usually appear in prison education curricula, so such activities are more likely to attract independent funding. As well as their therapeutic, educational and rehabilitative benefits they provide moral-boosting prison-camp style entertainment, and are considered good value for money by the authorities.

So social arts organisations wanting to provide art or craft programmes in the criminal justice system must persuade Governors and Heads of Learning and Skills that these programmes offer inmates a very different experience from the art class. Artist and experienced social arts project co-ordinator Sarah Butterworth describes the special dimension found in artist-lead workshops: 'They are more a group project, requiring communication and social skills, whereas classes are geared towards individual achievement, more knowledge-based. Workshops have a unique character stemming from the artist.'

Like Sarah Butterworth, Sylvia Edwards has taught accredited art courses in prison education departments as well as delivering independently funded workshops, and now runs 'reparation' arts programmes for young offenders: 'Accredited courses have a more secure structure. Non-accredited workshop programmes – however well planned – have the element of chaos and chance: resourcefulness and innovation are to the fore.' Angela Findlay – an artist with over ten year's experience working in German, Australian and UK prisons – says: 'Workshops are more intense, and the group dynamic more critical, more gritty.'

Even so, as community artist Douglas Nicholson has found, such projects will usually need certification in order to fit funding criteria. He is sceptical about this, believing that the benefits inmates gain from working creatively in small groups can't be measured by such pro-scribed learning outcomes. But he and others like him working in the Criminal Justice System (CJS) have learnt to 'map' their creative programmes to qualifications, usually 'key skills': these measure social skills against learning outcomes such as assertiveness and decision-making. Sarah Butterworth acknowledges: 'qualifications are good for prisoners, and that has to come first. The certificates may not count very much in the employment world, but in terms of self-esteem they are certainly worthwhile.' Angela Findlay also feels that 'qualifications are necessary to fit programmes into the prison world so they have a

chance to become real policy. Apart from that it's a piece of paper, an achievement, a certificate. It's certainly worth building in other aspects such as anger management.'

However, it is not easy to persuade governors to let artists into prison, and artists with experience of negotiating and managing projects in the Criminal Justice System talk of the tepid attitude of prison regimes. Angela Findlay devised and delivered the Learning to Learn art workshop programme for the Koestler Trust in several prisons: 'You were totally dependent on personalities; making arrangements was completely down to individuals, but they didn't necessarily have the power or responsibility to push things through.' Project-coordinating the same programme for the Anne Peaker Centre Sarah Butterworth found that 'the most difficult thing is getting good attendance at workshops, which involves several issues such as communication with officers and commitment from the regime'. She sometimes got the impression that prison authorities saw such activities as not making much difference, wondering if perhaps art and the security environment were inevitably set at odds with each other. Both have found the Criminal Justice System an exasperatingly unpredictable environment to work in.

Apart from these systemic difficulties, artists working with offenders in closed conditions speak of other challenges which are part of the daily lives of those who live and work inside. Sylvia Edwards described her initial feelings of vulnerability in a Youth Offenders Institution:

If you're working for any length of time with inmates you get to know what they're in for. It bothered me quite a lot how they were dealing with what they'd done. Low self-esteem and the prison environment, where everyone has to watch their backs, makes coming to terms with guilt and remorse very difficult, as everyone has to be seen to be tough. It did bother me before I went in, but when I got to know the lads better, I stopped feeling threatened. But I didn't get any support. As an artist people do open up to you and you take on a lot of shit, but you never have any download time, no organised opportunity to talk to anyone. Whenever it was break time the regular education staff spent these ten minutes sharing the most harrowing things, how they were bullied etc.

Another said: 'things leak out – I'm always intrigued about their offence, but it's nice not to know; I don't want to be distracted. I have never worked with sex offenders, but in the same way that they are part of the offending spectrum, creative programmes in the CJS must be inclusive, irrespective of the crime.' Particularly for women artists working in male establishments, this last issue is a sensitive one. One worked briefly with an inmate who had killed several women without remorse, and found him so unpleasant she threw him out of her class.

Mostly though these artists talk positively of their experiences of working with offenders, and think that what they do is beneficial for all participants. Sarah Butterworth believes that:

artists are very good at withstanding judgement – there isn't necessarily any right or wrong in workshops, everything's valid. It's good to bring in the concept of non-judgementalism; it helps people participate more freely.

Artists can be very good at developing resourcefulness in prisons, using things in different ways (though of course they are already known for this!), but you can help them see things differently, and give their environment new meanings.

Matthew Cort believes that prison artists and art students benefit enormously from learning about and, if possible, working with contemporary artists. After all, they see them regularly on TV: why not first-hand acquaintance? Prisoners may not be able to visit galleries, so why not get galleries to visit them? Cort argues.

He has worked in prison art education for 24 years, both at HMP Pentonville and HMP Wormwood Scrubs. During this time he has not only continued his own creative vocation as a sculptor, but has organised a number of collaborative projects between artists, galleries and prison art students. In line with current practice he considers these curatorial activities to be part of his work as an artist. Cort's projects have required energy and dedication well beyond his prison art tutoring remit: 'If I'm doing something which I'm interested in and it helps me as an artist, I'll do it for nothing.'

In 1993 he arranged for several Aboriginal artists visiting London for an exhibition of their work at the Hayward Gallery to do workshops with prison art students at HMP Wormwood Scrubs. This successful collaboration with the South Bank Centre's visual arts education department led to a further project with the artist Julian Opie the following year. Opie was attracted to the prison environment, and decided to recycle a piece from the retrospective exhibition of his work then showing at the Hayward Gallery. He was keen that his project not be an educational one, and Cort believes that this 'creative selfishness' ensured a more enduring project. He arranged for Opie to paint a series of urban 'wallscapes' on the inside of the perimeter wall, which can be partly seen at angles from prison windows; the arid character of the work fitted its setting well. Security objections to the use of ladders were eventually overcome, and Opie and his assistants worked with 'D category' day release prisoners and those about to be released.

A contribution to 'Cow Parade' followed in 2002. These life-size fibreglass models of cows continue to appear in cities all over the world, decorated by local artists or community groups. Cort asked if the prison could participate, and two life-size cows were subsequently decorated: *Tattooed Cow* and *Cowmooflage*.

Cort said: 'There are over 60 separate tattoo designs on *Tattooed Cow*. About a third of these are copied from the bodies of the prison inmates, approximately a third are inmates' own designs, and the remainder are mostly exciting designs chosen and adapted by the group responsible for

opposite: Cort/WS, *Wallscape 1,* Masonry paint.

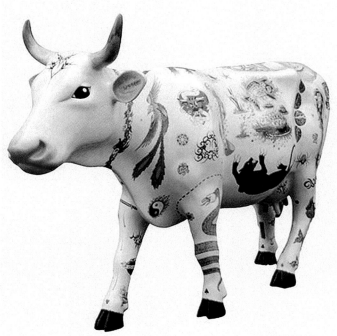

executing the work.' Both cows were eventually sold at a charity auction.

Most recently in 2005 Cort approached Artangel who had commissioned the large-scale video documentary piece 'Kuba' from Turkish artist Kutlug Ataman. Ataman's installation consisted of multiple filmed interviews from the inhabitants of a shantytown outside Istanbul. They described their lawless and frightened lives, many of which had featured prison sentences. Cort arranged for several of the TVs with their video stories to be installed in HMP Wormwood Scrubs after Ataman's exhibition had finished.

NOTES

1 Interviewed for *Prison Service Magazine* (October 2008).

2 Except those too old to work – see 'Late Starters' (p. 14).

3 Not all – some northern prisons use ABC accreditation.

4 A locked Perspex-covered wall cupboard for storing potentially dangerous tools in retaining clips against their silhouetted shapes, with a corresponding tally system.

5 The National Prison Service 'Incentives and Earned Privileges' scheme consists of three levels of privileges: Basic, Standard and Enhanced; each level offers different privileges obtainable by the prisoners depending on their security status, e.g. increased frequency of visits or greater phone access.

6 There is further information about muralist Daren 'Wolfie' Bishop in Chapter 5 on muralists.

7 'Providing that Governors meet the demands of the many standards and performance measurements, they have considerable autonomy to run their establishment in their own style. This often accounts for the diversity between establishments. The nature of the career structure means that there is frequent movement of Governors. Therefore, changes in the style and emphasis of establishments also fluctuate,' An introduction to working with the Prison Service, HMPS, June 2002.

8 Volatile Organic Compound – decorative coatings with high VOCs contribute to atmospheric pollution: EEC directives now require these to carry health warnings.

9 For more information on this subject, see 'No problems – old and quiet', Older prisoners in England and Wales, London HM Inspectorate of Prisons, September 2004, and *DOING TIME: the experiences and needs of older people in prison*, Prison Reform Trust, 2008.

10 Those living by the Nazarite vow implement Moses' Law: no flesh, no vine, no alcohol. They also advocate the use of herbal medicine.

opposite, above: Julian Opie, *Wallscape 2,* HMP Wormwood Scrubs, masonry paint.
opposite, left: Matthew Cort, *Tattooed Cow*, acrylic.

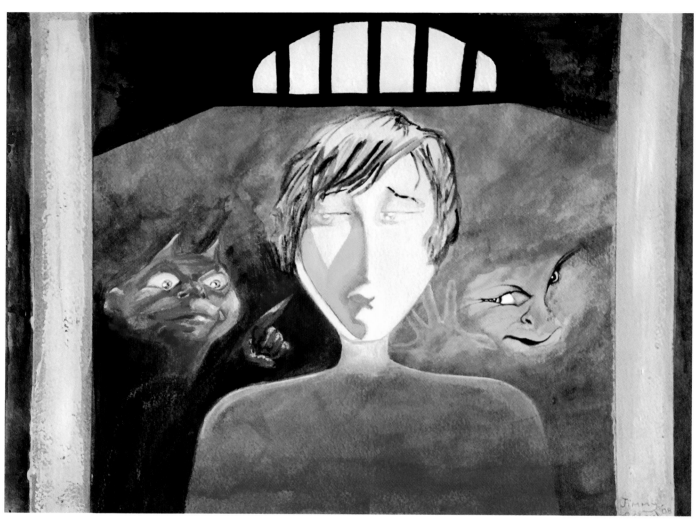

Jimmy, *Paranoia,* acrylic.

3
Prison Arts & Crafts

Those incarcerated for long periods have often made things to pass the time. Whether convicted civil prisoners, prisoners of war, internees, political detainees or psychiatric patients, they have carved, modelled, scratched, drawn, tattooed or painted to fill long, slow hours, depending on what tools and materials were available, as well as their own resourcefulness and ingenuity.

During the Napoleonic Wars over 122,000 French soldiers and sailors were held as prisoners of war in hulks and depots, or prison camps across the UK. Outside the depots markets took place regularly where French POWs sold craft work. Depot agents supervised the sale and price of items sold, as well as the provision of raw craft materials. Prisoners made toys, chess sets and other small items carved from bone and other materials as well as scale models of war ships.[1] Some of these prisoners took small fortunes home with them when they finally returned to France.

It is most probable that these prisoners of war had been naval seamen: making ships in bottles and other carefully crafted objects have long been traditional pastimes for sailors on long sea voyages, providing a sub-genre of this category of Slow Art. Herman Melville described in his novel Moby-Dick how 19th century American whalers carved small artworks:

...skrimshander articles, as the whalesmen call the numerous little contrivances they elaborately carve out of the rough material, in their hours of ocean leisure. Some of them have little boxes of dentistical looking implements specially intended for the skrimshandering business. But in general they toil with their jack-knives alone; and with that almost omnipotent tool of the sailor they will turn you out anything you please.

The nearest any UK prison inmate will get to a jack-knife is the blade removed from a disposable razor,[2] but in the service of prison craft this can be put to versatile use, carving and whittling soap and any other material which comes to hand. It's another matter in the art room of the prison's education department (known as Education), where a locked wall cabinet may well hold a range of cutting tools for students' use. Which is not to say that

the rest of the disposable razor can't also serve creative ends: working in his cell at Maidstone prison, Jody made this skull by melting disposable razors together with his cigarette lighter. Here is adroit artistry characteristic of prison craft, expressed so vividly through the recycled use of ephemera.

Generally however TV and the widespread use of electronic games in cells have seen traditional cell-based art activities decline; similarly, more regular phone contact with loved ones has lessened the need for other traditional prison art skills such as decorated handkerchiefs[3], illustrated letters and envelopes, although others, for example tattooing, soap carving or matchstick modelling, persist. Match manufacturers produce uncoated, headless matches especially for the model-making market, and most prison canteens sell bags of these as well as plastic match trimmers. (Some years ago Bryant and May lost the UK prison match-modelling contract to Swedish Match.) Kits of Romany Caravans, the Eiffel Tower and suchlike are easily available from hobby catalogues, but work of any artistic interest is individually designed. Stephen made his 60 centimetres-high matchstick model castle in the Bavarian Schloss style in Kemple View secure unit.

right: Jody Head, *Skull*, disposable razors.
far right: Stephen Smythes, *Castle*, matchsticks.

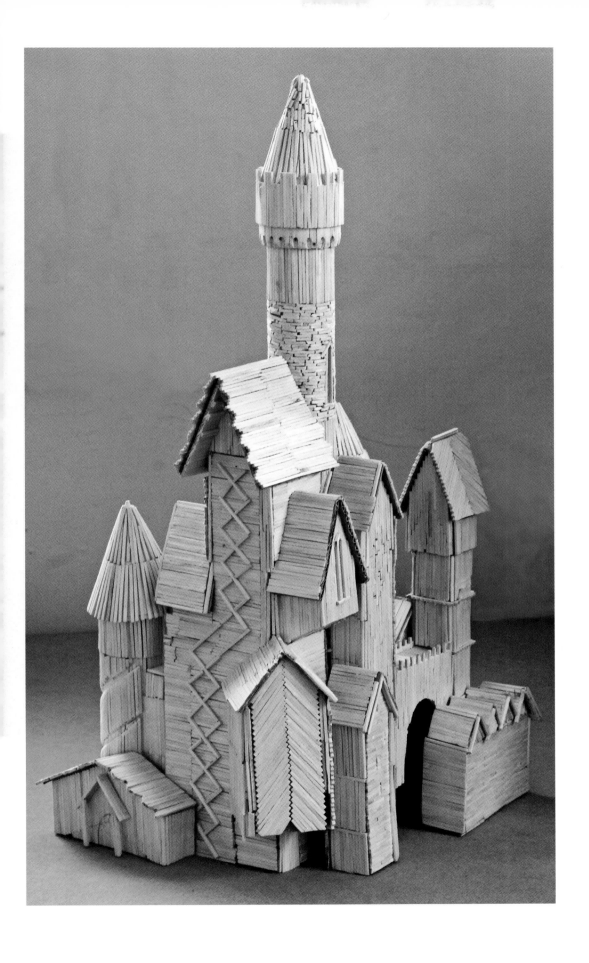

Michael made this shack at HMP Wakefield, dubbed *Povey's Pigsty*, from memories of working in the building trade. Tung Pham's football stadium is one of a series of sports dioramas he made at Brinsford Youth Offenders Institution.

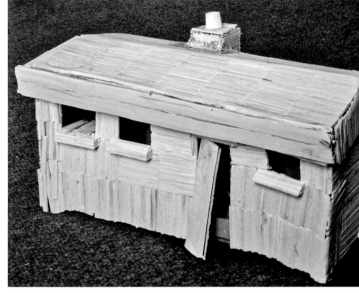

above: Michael Povey, *Povey's Pigsty*, Matchsticks.
below: Tung Pham, *Football Stadium*, Card.

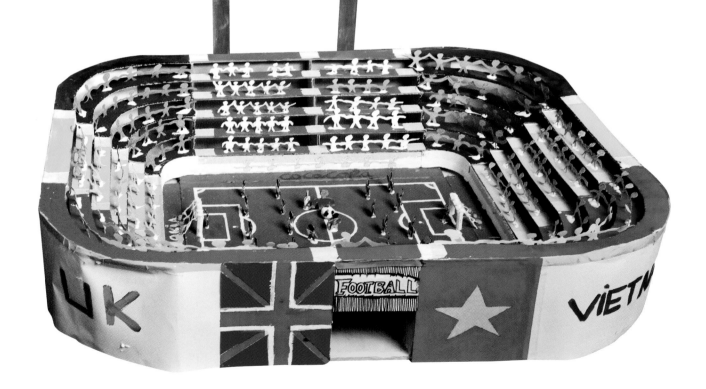

THE ALL ROUNDER

When I first met Jimmy he was 55 years old and two years into a 14-year tariff. A one-off family-related shooting had put him inside, a sentence twice as long as expected, probably because of his social connections with known South London crime figures. Comfortably large, friendly and outgoing, Jimmy had built up a successful construction business in Southeast London, with property interests in Spain. How do people survive such dramatic reversals in life? Yet he seemed so resilient, even cheerful, talking enthusiastically about his several commitments in the prison. He was a Listener – a sort of prison Samaritan – and worked for the St. Giles Trust, the prison charity which helps prepare inmates for release. He was also a peer advisor, helping much younger and more helpless inmates find their feet. And he had been talking about helping foreign nationals, putting his Spanish and Portuguese to good use.

Very much a family man, Jimmy's wife and three teenage children visited him regularly in prison:

My art began as communication to my children. After I came to prison, we would sometimes run out of conversation on the phone, so I started sending them pictures for us to talk about. It then expanded to prison life and illustrations, accompanying poetry and newsletters.

Jimmy had enjoyed art at school and said he had daydreamed then about being an artist, but the necessity of making a living put paid to such ideas, until prison – and now he was talking about building himself a studio on release. Once inside, a creative vocation had flowered. To begin with he traded portraits of other inmates and cartoons for their kids in exchange for fruit and art materials. Then his art found subject matter in the ready sources of prison life and its daily challenges: Jimmy recorded characters and encounters in poems, stories, drawings and cartoons (see p. 58–9).

He was encouraged in all of this by Mark, the prison's peripatetic writer in residence, who spotted Jimmy's talent: he put his work in books, pamphlets, on posters and even postcards, as with *Got a Burn, Bruv?* (see p.58).

Insider Art

Got a Burn, Bruv?

A one-eyed Burn-Forager
Came to my cell this very day:
Morosely dripping guile.
He began his repertoire of play.
'Got a burn, bruv?'
'No, bruv.'
'Go on, got a burn, bruv?'
'Canteen tomorrow, bruv.'
'Got a burn then, bruv?'
'No, bruv.'
His roaming, bulbous eye
Crept all around my treasured store
Dissecting all it scanned,
Hunting dog-ends on the floor.
Then as if he had never been
Or spoke of burn before,
He was gone in one fell swoop
To accost the lag next door:
With his sullen, cynic sneer
Twisting to a contentious grin
Like an echo from the past
I heard him slipping in,
'Got a burn, bruv?'

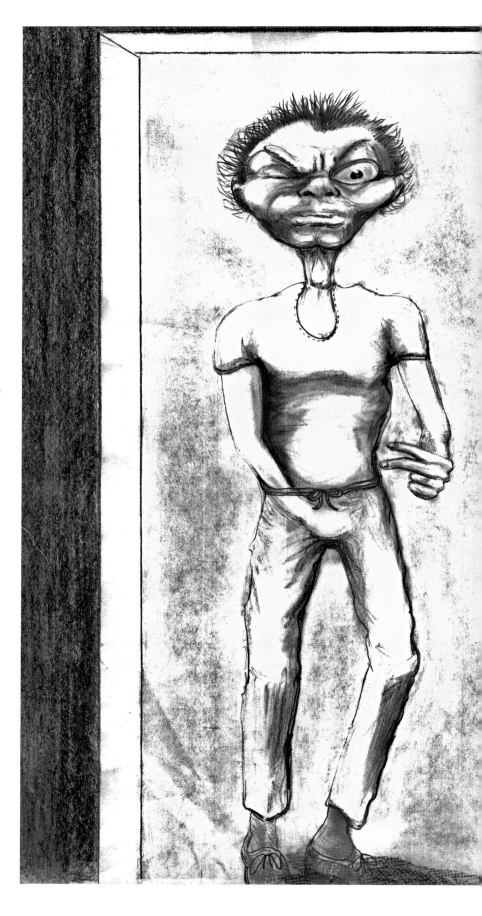

right: Jimmy, *Got a Burn, Bruv?* Pencil, biro, charcoal.
far right, top: Jimmy, *Peeking Out*, pencil, biro, charcoal.
bottom: Jimmy, *Banged up*, pencil, biro, charcoal.

Jimmy's talent flowered so well there had been attempts to rein him in on the grounds that other inmates should be given a chance at the prison's annual exhibition in the local library.

His modelling and sculpture had started when he had admired the matchstick models of a fellow inmate on his landing. Put off at first by his Mohican haircut and shaved-off eyebrows, Jimmy then discovered he'd been an engineer with Ferrari -– 'never judge a book by its cover' as he told me. He taught Jimmy some simple

technical drawing and how to do the suspension for the Harley Davison he was making for his son. Later on Jimmy went to art classes in the Education Department, but most of his artworks were made in his cell: jewellery boxes, motorbikes, 3D pictures, picture frames, doll's house furniture, eggs, flowers, sculptures.

Much struck by the multi-cultural nature of custodial life – Jimmy's prison in particular took in foreign nationals via two local airports – he had done some low-relief 3D pictures depicting

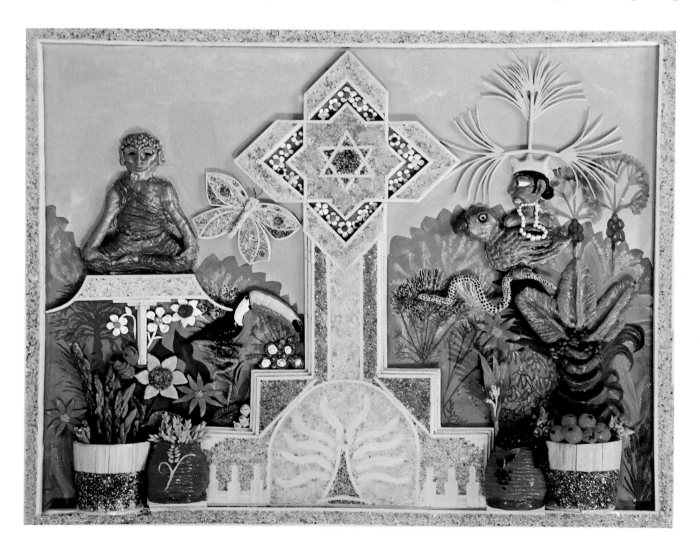

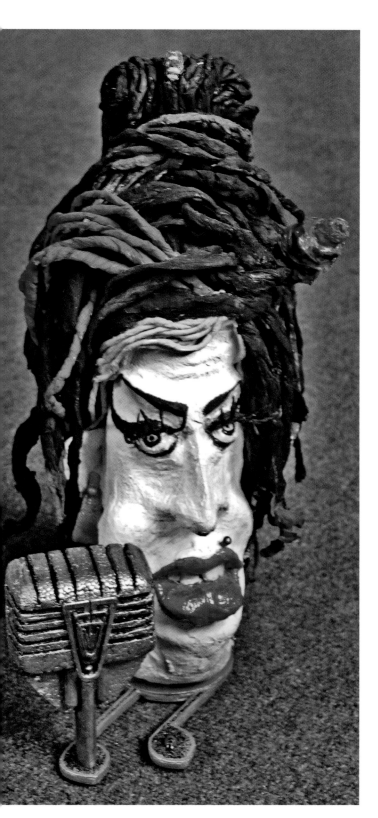

different religious symbols like the star of David, the Islamic Crescent, Buddhist and Hindu figures. They are beautifully made, with original colour schemes which seem to have the fresh colour-coded functionality of a Tanka cloth.

Jimmy enjoyed prison's time-honoured tradition of scrounging and ingenuity: 'I use materials I can obtain in and around the house block – PV glue, paper, matchsticks, eggshell, bread, coffee, salt, pepper, paper clips, almost anything I can forage legally.'

But why this resourceful foraging? Comfortably off compared with most other inmates, Jimmy shouldn't have wanted for much in the way of art materials. But it's getting harder to get stuff sent in, and longer-serving prisoners talk of the days when craft supply catalogues were more obtainable, and health and safety didn't hold such sway. Perhaps too Jimmy was reviving a more personal tradition of foraging; his father and brother had been East London dockers, and he remembered when small the stream of strange food and other exotic goods they brought home out of ships' holds – Uggli fruit, Boars Head Gin – Christmas-like displays of plenty. He made this portrait of Amy Winehouse after he started going to an art class in the Education Department, working with paper pulp.

Unexpectedly Jimmy died of a heart attack in his cell on the afternoon of the 12th of May

far left: Jimmy, *Diversity*, mixed media.
left: Jimmy, *Ms.Winehouse*, mixed media.

2008. He'd nipped into his cell to spruce himself up for a family visit – his wife and children were waiting for him down in the visits hall. It was five hours before they knew what had happened, by which time Jimmy's body had been transferred to hospital. His family were then given the name of the wrong hospital. That night there were two attempted suicides in Jimmy's prison, one successful. Several more attempts took place during the following week, a distressing tribute to Jimmy's pastoral power. A big man, he'd been joking with writer Mark a few hours earlier that he needed to get back to the gym. His cell neighbour Gary had found him dead in his cell, begging the question as to whether he might have survived elsewhere. I could only guess at his family's grief, but knew that in prison his invaluable gifts of empathy and compassion were badly missed.

THE TATTOOIST

The association of tattoos with criminal gangs and prison may have originated in their being used for publicly branding convicts, as practised in England in the early 19th century, for example when the letter D (for Deserter) was marked on some of those deported to the colonies. In Japan, the origin of *Yakuza*[4] body suits – all-over tattoos – can be traced to earlier *Bokukei*, or punishment by tattoo. In other contexts (sailors, the armed forces and in concentration camps) tattooing has been used primarily for identification. Banned in prisons, the practice there continues, indicating gang membership, toughness and refusal to accept authority. It is a form of defiant self-expression authorities can punish but not confiscate – and so tattooing persists in prisons across the world. Danzig Baldaev's recently published volumes of Russian criminal and prison tattoos suggest that their arcane iconography of secret codes has flourished most in countries with 'closed' or repressive penal systems, and since the Gulags were closed in the 1990s the practice has declined. In the UK similar codes or messages such as the knuckle initials ACAB (all cops are bastards) are mostly a thing of the past.

What about tattooing in UK prisons today? Although information is hard to come by I interviewed a practitioner in HMP Cornhill in Shepton Mallet, Somerset. In his early 40s, Arnold is coming to the end of a life tariff, and has been in prison for 19 years. Britain's oldest operating prison, this unique C category

training prison was built in 1625 and caters exclusively for long-term lifers coming to the end of their sentences, mostly men in their mid-30s and upwards, finishing off their time. There's a more orderly and less excitable atmosphere – no young prisoners in for Gladiator School.

Mostly[5] the prisoners will go on to the open conditions of a D category prison, their final stage before release. Sometimes though they can't cope with the relative freedom and end up back inside, being unaccustomed to the lack of walls, locks and other restraints; some would say insufficiently prepared for independent living. This happened to Arnold, and after a year in HMP Cornhill he's now hoping to be reconsidered for a 'D cat'. But he'd just had an unfavourable Psychology Report, and had requested an independent one. In the mean time he's two years into an Open University course in Geosciences; perhaps this will improve his chances of being moved back to open prison, that and his web design qualifications. What he actually wants to do on release is run a mobile tattoo parlour, but he can't say that. Arnold Pickering is a tattooist, and although tattooing is perfectly legal outside, over his 19 years inside he has had 17 discipline reports for practising his craft.

As part of the prison's 'preparation for release' programme he had recently visited Weston-Super-Mare on a shopping trip. He came across a tattoo parlour, and was shocked at the prices. Unlike other illicit activities inside, his charges are a fraction of outside rates, starting off at £10 for a short text. Although he once charged £500

for a full back job, it's usually well under £100. Because he is doing his time alone, he relies on this income to provide for himself. Without visits, and without a support network outside, resources are limited. He believes his charges reflect the quality and cleanliness of his work, and is wary of the standards of other prison tattooists. One at Shepton Mallet has just been shipped out – 'he was a botcher: if you go too deep, the skin tries to knit itself back together again, and you get a mess'. Tattooing is illegal in prisons partly because of associated health risks, and Arnold is very conscious of this. 'I take pride in working cleanly, even aftercare, though I've several antibiotics stashed around the prison just in case. There can be problems working around arm and leg joints.' Hepatitis B is the main issue: 'I go down to healthcare every six months for a Hep B check, because of contact with so many.' He always wears surgical gloves when working, and gets these when they are issued to inmates for cleaning their cell toilets.

He thinks he's done nearly 700 tattoos in different prisons, and much of these have been 'cover work'.

Normally you get a tattoo when you want to remember a good time you've had, to show your love for someone, or they're about belonging, identity. When these things can change, it can be very upsetting to be reminded of a part of your past you're trying to forget. I can disguise names and change designs for customers. But I prefer to work on fresh skin, a fresh canvas. As an artist it is my work

Arnold, *Sketch of rotary tattooing machine*, biro.

then. I don't particularly enjoy working on other people's work.

He has also worked with self-harmers: 'This is tricky because you can't tattoo scar tissue as it is dead skin. Needles only work on living, porous skin, but I can hide the scars in the design.'

Arnold has no contact with the art department, so gets his materials from outside. Sometimes others have ink and other material brought in, but Arnold has no visits or family to speak of (his two half-brothers have severed all contact).

For line work he uses Winsor and Newton waterproof inks, and bodies up Rotring inks with some white to do colour areas. Sometimes as part of the deal customers provide materials. As for the tattooing gun: 'Traditionally people use cassette players but I've found a VCR motor is steadier, and it runs on 12 volts.' I don't ask him how he got to cannibalise a VCR in prison. The hammer mechanism which pierces the skin whilst feeding colour down the tube has a cam which activates the trip. 'I buy sets of Berol pens and use the tubes. I use guitar strings as needles and trim them off regularly so there should be no biological contamination.' He doesn't play the guitar himself, but a friend does, who orders extra sets of strings in for Arnold.

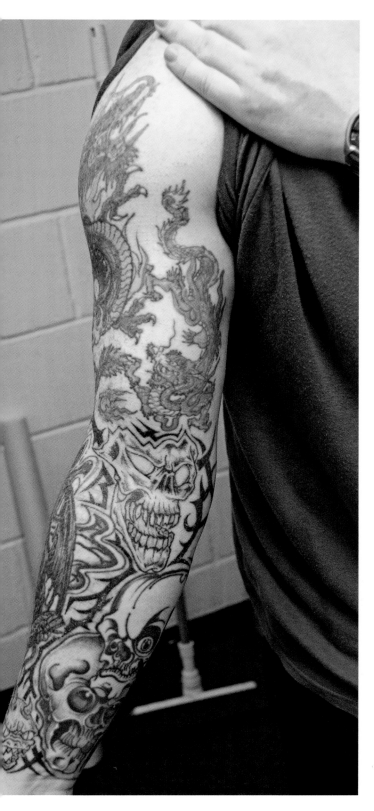

As for his artistic background, there were no significant influences though he says he enjoyed art at school. When he left he got a sign-writing job, a background as useful as any for a craft as intimately involved with text as image. He considers his art education got under way in prison, certainly the tattooing did. Self-taught from three books of tattoo flash, or designs, he now seems to have internalised its decorative glossary and no longer needs them: 'I'm not methodical, but I'm so confident now that I can work directly.' Although his art can be seen in prisons all over the country, he feels he has no formal avenue for submitting work such as the annual Koestler Award Scheme. 'For me the good thing about this book is that it'll show there are professional standards in doing it. There are people here with horrendous body disfigurement, and considering that I've had to do it with equipment I've made myself, it is well up to the professional standards outside.'

Perhaps the most impressive aspect of Pickering's tattoo work is its fluency. The images themselves are mostly stock-in-trade flash (tattoo designs), though I was unable to judge how up to date they are. However the drawing and distribution of designs are confident and beautifully executed. When I asked to photograph his work he told me to wait in the little office where I had been interviewing him in the prison education department, and returned shortly with four former customers. All were happy to show off his work.

Arnold, *Customer A, inside right arm*, tattoo.

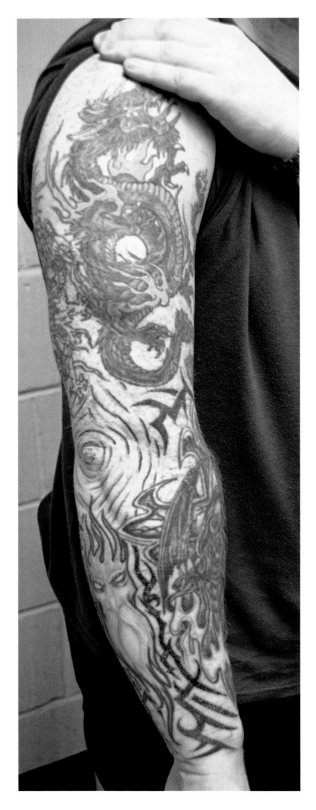

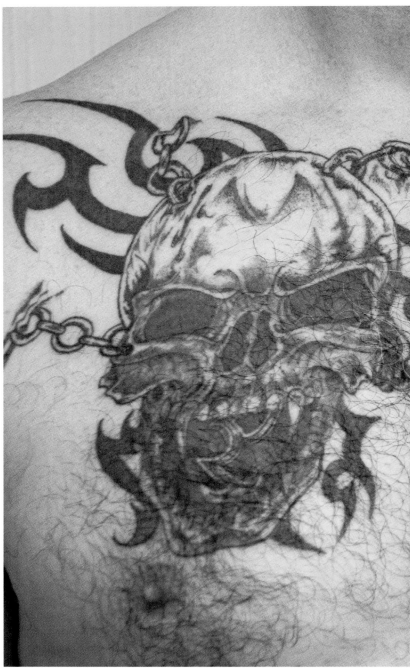

Arnold, *Customer B, chest*, tattoo.

Arnold, *Customer A, right arm*, tattoo.

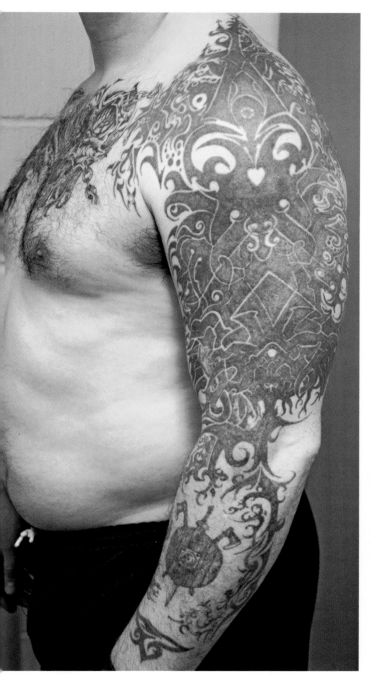

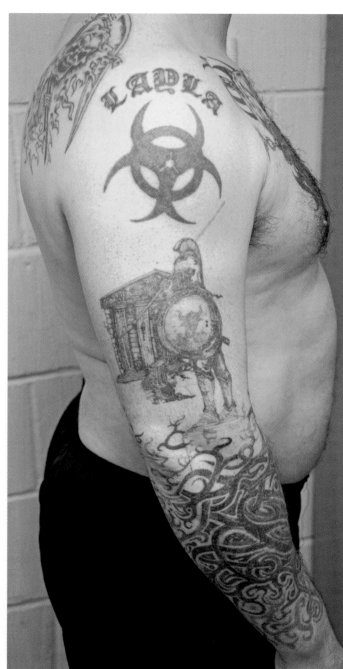

Arnold, *Customer B left arm & chest*, tattoo.

Arnold, *Customer B right arm & chest*, tattoo.

THE SOAP CARVER

John was recently released from prison after a two-year sentence. This was his longest to date: now 41, he has been in and out of prison all his life, serving custodial sentences for most motoring offences including speeding, dangerous driving, procurement by unfair advantage (using false documents), driving without licence or insurance. His defiance and disregard for 'the system' dates back to a serious bike accident in which his leg was crushed. The lorry driver responsible got three points on his licence and a £120 fine. John was outraged at the leniency of the judgement and seems as a result to have lost faith in the law and all forms of authority.

He should have been released earlier, but was turned down for a tag because he failed to address his offending behaviour. He had refused to do any of the prison's offender behaviour programmes, and, now on probation, has been asked to do another, Think First.[6] John told me:

Basically they're trying to force me to jump through hoops, and I'd rather go back to prison. You give me any reason why I should change, because I can't think of any. This will be another big sticking point for me – only going out on the bike calms me down. That's what makes me laugh about prison psychologists, they're tinpot fucking twats. You can't read between the lines with me, I'm brutally honest with them so they're fucked.

John's disdain for representatives of criminal justice in any form has some exceptions:

Occasionally you find some good prison officers, if you've got a problem they'll actually try and sort it out, but mostly everyone's corrupt in prison. I watched this inmate dealing crack from the showers and a screw [prison officer] was feet away, taking absolutely no notice. When I was last inside screws were going round the 4s [4th floor landing] offering tenners to inmates for grassing up those with mobile phones.

He saw another prisoner carving soap whilst serving a sentence at HMP Erlstoke in the early 1990s, and took it up himself. In 2007 during John's most recent sentence the art co-ordinator in the prison's Education Department heard about his hobby from a prison officer and got him up to Education, where he developed this traditional prison craft in the art room. He had been carving mostly motorbike model numbers as well as private commissions, working on bars of prison soap with paper clips and disposable razors. In the art room he got larger and better quality soap bars, as well as legitimate access to 'carving tools' such as compasses and craft knives. He began to do more ambitious projects, looking at art books for inspiration and was guided by another tutor whose own art practice was sculpture. But John resented any pressure to complete accredited courses, seeing it as yet another form of restraint imposed by the prison authorities. The art co-ordinator would get fed up with him: 'He would spend so much time

top left: John Ryman, *Adam and Anitia (JR3)*, soap.
above left: John Ryman, *Happy Birthday Princess (JR4)*, soap.

above: John Ryman, *Ridin' my bird*, soap.

working on commissions, I kept on warning him, but he refused to do qualifications. He couldn't see the point of going on the education journey.' Despite this John remained in the art room, both because of the quality of his work and in acknowledgement of his art awards and inclusion in exhibitions. His says his proudest moment ever was exhibiting work in a prison art exhibition at the ICA in London. The manageress of his local pub commissioned four carvings from him recently, though he knows it won't make him a living, nor keep him out of prison.

Notes

1 For further information on this subject see *Prisoner-of-war Ship Models 1775-1825* by Ewart C. Freesston, Nautical Publishing Co., 1973.

2 All prison security departments have 'museums' displaying confiscated weapons improvised by inmates.

3 In the USA Paño art still thrives: this is the traditional Chicano prison art of illustrating or decorating handkerchiefs, and has both religious and gangland origins.

4 Japanese mafia crime syndicates.

5 During 2006-2007 only one prisoner was released directly.

6 Think First is a CBT-based offending behaviour programme for repeat offenders run by the National Probation Service.

The Art of Internment

Unsurprisingly perhaps artists have regularly been imprisoned or detained over the centuries: some, like Courbet, Daumier or Wang Du for their outspoken political beliefs, others sentenced like Caravaggio for criminality, and many detained or interned during wartime. Max Ernst and Hans Bellmer were amongst many artists held at the Camp des Milles outside Marseille during the Nazi occupation of France.

Successive UK governments have used internment camps to hold 'enemy aliens' amongst other policies to control internal security. However these have usually lost public support and become politically counter-productive, most recently when introduced into Northern Ireland in 1971 (against the advice of the British Army). Soon after the outbreak of World War 1 the Alien Restriction Act became law, and foreign nationals, many of them naturalised, were interned. At the outbreak of World War 2, thousands more were interned in camps on the Isle of Man and the British mainland under the same law. Many of these were cultural refugees from the Nazis such as Klaus E Hinrichsen, art historian and German internee in Hutchinson camp on the Isle of Man during World War 2, who described internment as 'a weapon used in wartime by governments to protect citizens against resident foreigners of enemy nationality' (*Living with the Wire*, Manx, 1994). Despite the restrictive conditions, much creative activity took place, both as a focus for communal life and in the artistic communities which coalesced at different camps. Hutchinson camp on the Isle of Man held many artists, including Kurt Schwitters, and John Heartfield was at Huyton Camp outside Liverpool along with Walter Nessler, Hugo Dachinger and others.

In the aftermath of 9/11, as we learn to live with increasing restrictions to civil liberty imposed by the Crime and Security Act of 2001 and the Prevention of Terorism Act of 2005, internment is back in the UK. The war on terror has put many Muslims in prisons and immigration centres where they are being detained without charge, held either on alleged immigration contraventions or unspecified terrorism offences determined by the SIAC (the Special

opposite: Cedro Zbigniew, *Cell window*, tempera.

left: Detainee 'B', *Large Vase*, ceramic.
above: Detainee 'G', *Small Vase*, ceramic.

Immigration Appeals Commission) court. When released, control orders amounting to electronic house arrest can make living conditions for them and their families difficult.

Detainees are held at Belmarsh, Long Lartin and Whitemoor[1] Category A high security prisons. The stress of open-ended detention has brought with it mental health problems including suicide attempts: many are under threat of extradition back to their home countries, where further torture may await them, even execution.[2] Despite these conditions, some detainees at HMP Belmarsh and HMP Long Lartin have managed to give creative expression to beliefs and feelings essential to identity and survival. At Belmarsh, several detainees held in the prison's High Security Unit had attended pottery classes run by prison art tutor and ceramicist Tunde Akinnniranye until November 2004, when his class was summarily closed down. It was clear that the pottery classes were helping to alleviate some of the mental health problems, until they shut down. I got to see the work his students had made at an exhibition organised by Cageprisoners at the offices of Together, the mental health charity, along with art and craft by Muslim detainees held in other prisons.

Detainee 'B' – the SIAC court prevents the use of real names – was an Algerian held in Belmarsh's High Security Unit on unspecified terrorist charges. During his detention at Belmarsh Prison he worked in the pottery class for two years. Over this period he made a large vase nearly a metre tall, thrown in three pieces then joined together. Tunde Akinninranye recalls him always asking technical questions: searching for its particular green-blue hue, he made many glaze tests until he found it. The vase was glazed and fired twice, masked with wax. A skilled craft background meant his ceramic work was of a high standard, sharing a clear affinity in its form and decoration with indigenous Berber pottery traditions, his own Kabylie region in particular. After the closure of the pottery class 'Detainee B''s mental health began to deteriorate, and he was transferred to Broadmoor high security special hospital.

Detainee 'B' had shared his cell with Detainee 'G', from southern Algeria. Though disabled by polio, he attended Tunde's class as well, making simple undecorated pots on the wheel.

Detainee 'E', another student in the Belmarsh pottery class, was Tunisian. Whilst there he made

74

an intricate model of the Jamiat-ul Zaytuna built from clay slabs. This is a portable version of the huge Zaytuna mosque in Tunis, and works as an emblematic *aide-memoire*, bearing only a notional resemblance to the original. 'E' was released in March 2005 and placed under control orders.

At HMP Long Lartin detainees are held on the Segregation Unit, normally used for isolating 'problem' prisoners. Until recently detainees went to art classes in Education, but their access to all education classes has now been prevented for unspecified security reasons. As in other prisons art and craftwork continue to be made on the wings, and Long Lartin's Segregation Unit is no exception. For several years detainees there have used a traditional prison craft, matchstick modelling. Kits of headless matches specially sold for this purpose are usually available in prison canteens, together with plastic trimmers and small bottles of PVA glue, which can also be diluted and used as varnish. As well as making more traditional objects such as jewellery boxes for wives and daughters, some have developed more ambitious projects, sometimes stained but uncoloured according to the convention which allows their intricate construction to be displayed.

Hussain Al-Samamra is Jordanian and has been interned at Long Lartin since 2006. After being tortured in Jordan he claimed political asylum in Britain. Under the threat of deportation he was granted bail at an SIAC hearing, and has

eventually been released under a control order. During his time at Long Lartin he made several matchstick models. To construct his sailing boat he built up curved surfaces for the hull and sail, sanding them smooth with a varnished finish.

The sail of this traditional dhow has Allahu Akbhar ('God is Great') in Arabic letters pasted vertically downwards. Alongside are photographs of The Dome of the Rock and the Kaaba, also

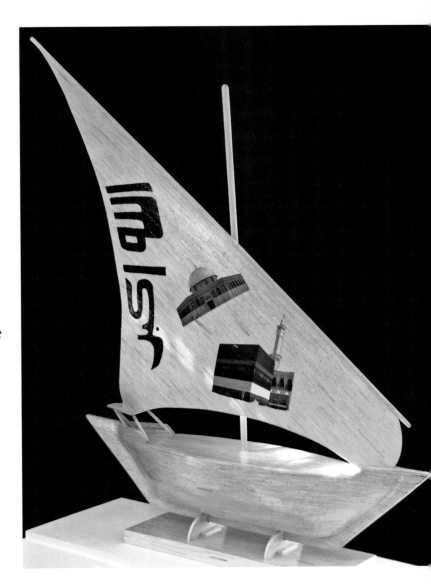

left: Detainee 'E', *Jamiat-ul Zaytuna*, ceramic.
right: Hussain Al-Samamra, *Dhow Allahu Akbhar*, matchsticks.

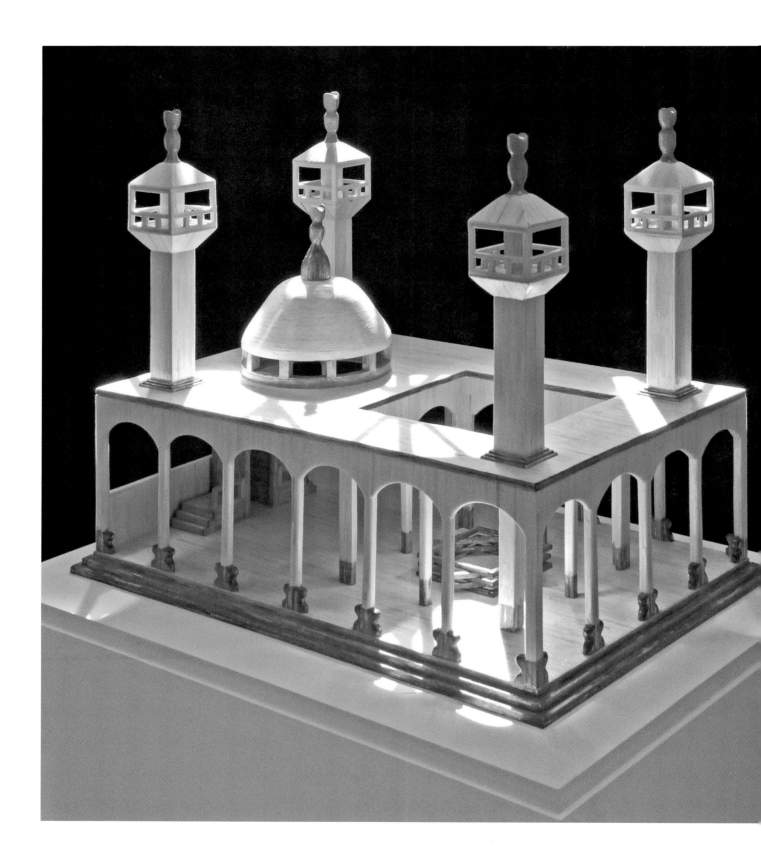

pasted on and varnished. The Andalusian Mosque is also made by Hussain Al-Samamara. Four minarets and a dome sit on top of this cloistered mosque, perhaps based on the eponymous Andalusian mosque in Fez. Its dome has been shaped from a solid block of matchsticks, as have the finials above the minarets. Hussain Al-Samamra has made a trinket box for his wife Najat. Two hexagons connect along one side, and her name is made up in striped match letters on the lid: red, white and green – together with the lid's black outline, the colours of the pan-Arab nations, including Jordan's own national flag.

Prisoners are held at Immigration Removal Centres for various reasons: they may have had their appeals for asylum rejected, have infringed immigration procedures or have had their resident status reconsidered after a conviction and custodial sentence. Many of those held at IRCs face separation from families or uncertain futures if repatriated, and can remain in limbo for indeterminate periods. As with the Muslim detainees described above, the stress of open-ended detention can worsen mental health, incurring anxiety and depression. And indeed, when I visited him in Haslar IRC outside Portsmouth, Cedro Zbigniew was very depressed. Despite having completed his two-year sentence seven months ago he was still detained, awaiting news of his appeal

left: Hussain Al-Samamra, *The Andalusian Mosque*, matchsticks.
above right: Hussain Al-Samamra, *Trinket box for Najat*, matchsticks.

against a deportation order; with family, friends and a job awaiting him in London, he felt his future lay in the UK. A Polish national, Cedro had come over to work in the British building trade, but whilst serving his sentence at Pentonville he had rekindled his lifelong interest in art and decided he wanted to pursue it more seriously. He had taken part in several prison art projects, passed several art exams and had hoped to further his studies with an art and design access course on release. According to Carolyn, his prison art tutor, he was head and shoulders above his contemporary inmates. As well as careful watercolours (including this meticulous view through his cell grill, (see p.70) he worked proficiently in several styles all quite different from this: figure compositions based on movie stills (*Lovers*, painted in the

style of co-patriot, Tamara Lempicka, based on Lord Snowden's portrait of Christopher Lambert and Andie MacDowell as Tarzan and Jane in *Greystoke – the Legend of Tarzan, Lord of the Apes,* 1983), imaginary impressionist landscapes and flower studies.

Whilst at Haslar Cedro had been commissioned to paint a mural in the safe care cell. This was a holding room for those in danger of harming themselves or others, its main design feature being a lack of sharp corners. Working to a 'tranquil' brief, he had covered the wall with English fields and a country house. Outside the house, sitting alone on a bench, a woman waits alone. Cedro can be seen in the corridor outside.

Cedro's appeal against deportation was unsuccessful, and he was eventually sent back to Poland.

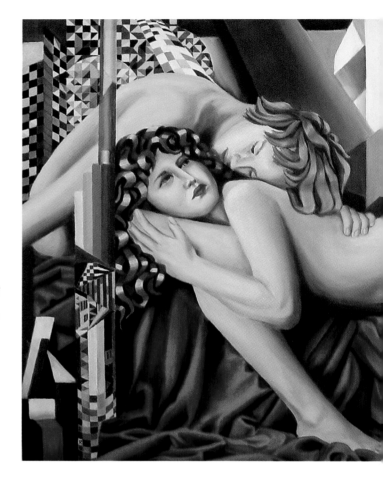

above: Cedro Zbigniew, *Lovers*, acrylic.
opposite, top left: Cedro Zbigniew, *Artroom flowers*, acrylic.
top right: Cedro Zbigniew, *Saferoom mural 1*, acrylic.
bottom: Cedro Zbigniew, *Saferoom mural 2*, acrylic.

Notes

1 As at June 2009, 73 in HMP Whitemoor alone.

2 'The most glaring gap in provision was the absence of sufficient and appropriate physical and mental healthcare support for detainees who were held in an extremely isolated and confined environment for an indeterminate period, often with a fear, or even experience, of torture or mistreatment overseas. Our own screening, using a well-recognised assessment tool, showed that the majority of detainees had diagnosable mental health problems, in some cases severe.' Anne Owers, Chief Inspector of Prisons, 'An inspection of the category A detainee unit at HMP Long Lartin,' HM Inspectorate of Prisons, January 2008.

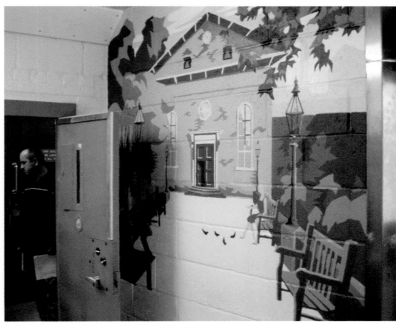

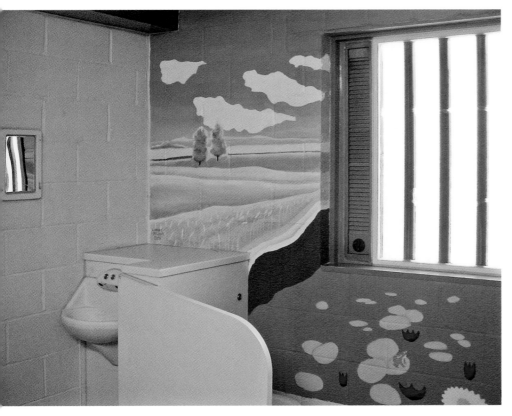

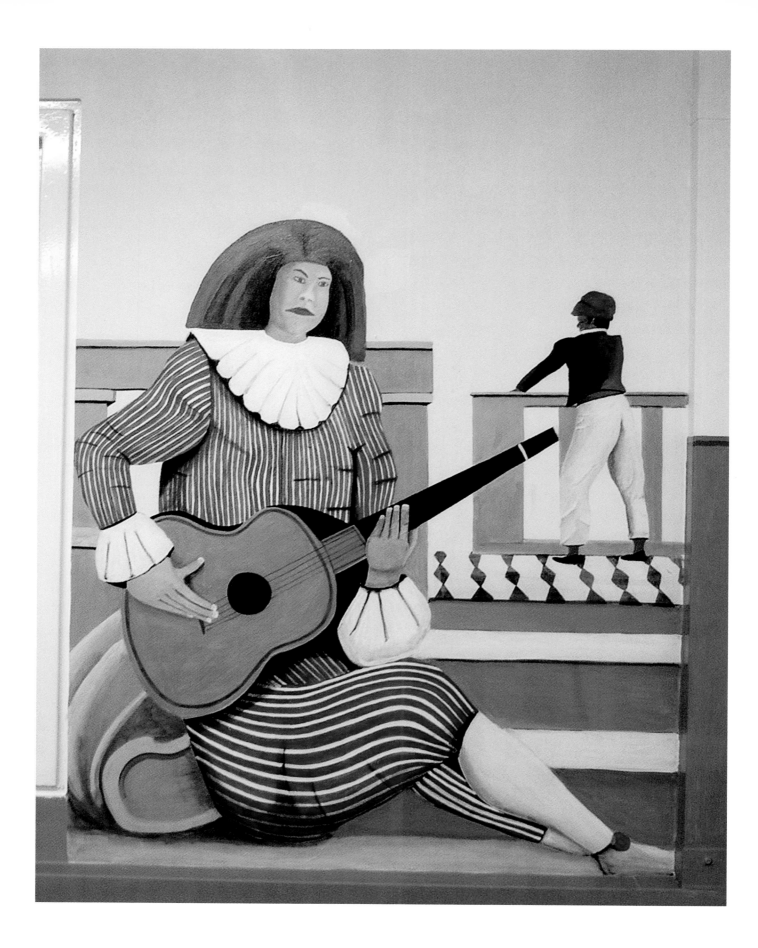

5 | Muralists

Chris Clarke has been held in the therapeutic community at HMP Dovegate[1] for five years. During this time he has decorated the therapeutic community's association areas with murals. These include scenes from Harlequinade – Princess Diana appears in one (opposite) – as well as a scene from the nativity story, *The Road to Bethlehem*. Also featured is Avonmouth and Bristol harbour, where Chris Clarke used to work as a tugboat skipper. He has also made several smaller paintings of the boats he knew so well.

Now in his late 50s, he has been inside for more than 20 years, and was inspired to start painting by Gordon, a tramp he met in Brixton prison. He saw him working in his cell, and thought, 'that's something I can do'. Entirely self-taught, he says he learnt his technique from watching Gordon work, and apart from art history classes at HMP Whitemoor has never received any formal teaching. Gordon sold work through the Burnbake Trust Prison Arts Project, and encouraged Chris to do the same. They sent him art materials, and he exhibited and sold work through the Trust, going on to do the same with the Koestler Trust. He is currently undergoing chemotherapy for throat and tongue cancer.

opposite: Chris Clark, *Recreation mural 2*, acrylic.

opposite page
top: Chris Clarke, *Recreation mural*, acrylic.
bottom: Chris Clark, *Road to Bethlehem*, acrylic.

this page
left: Chris Clark, *Avonmouth*, acrylic.
below: Chris Clark, *My Tug*, acrylic.

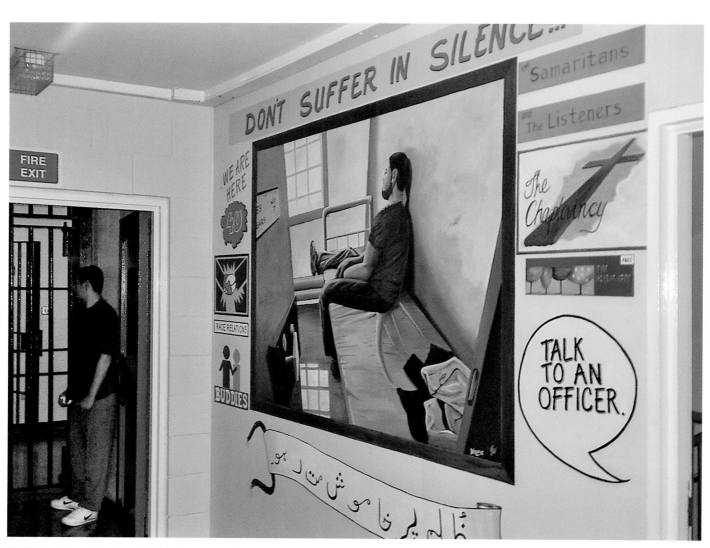

Wolfie Bishop, *Don't suffer in silence*, acrylic.

Daren 'Wolfie' Bishop, despite his evident creative vocation, doesn't do art in the Education Department either – he is employed full-time mural-painting by officers on different wings in HMP Littlehey. Subjects range from safety signs and posters advertising prison services such as St. Giles (the prison charity which helps prepare inmates for release) or the Listeners (prison Samaritans) to cell scenes, figure compositions featuring inmate portraits, and romantic landscapes including *Extracts from an African Sketchbook*. Describing the impact of his work on other inmates, Daren wrote:

I think the best reaction I've had to date was from an inmate on D wing about a year ago. Whilst I was over there painting the 'Extracts from an African Sketchbook', in fact on the day of its completion, I became aware of this guy standing behind me, which wasn't unusual. He didn't speak for a while except to say hello when he did, and he turned to walk away stopping for a last look and leaving me with a statement which made me feel so proud. He said that every time he feels down or angry, even to the point where he could hit someone, he walks to this picture and it makes him feel good about life again, then he left. I never saw him again but a

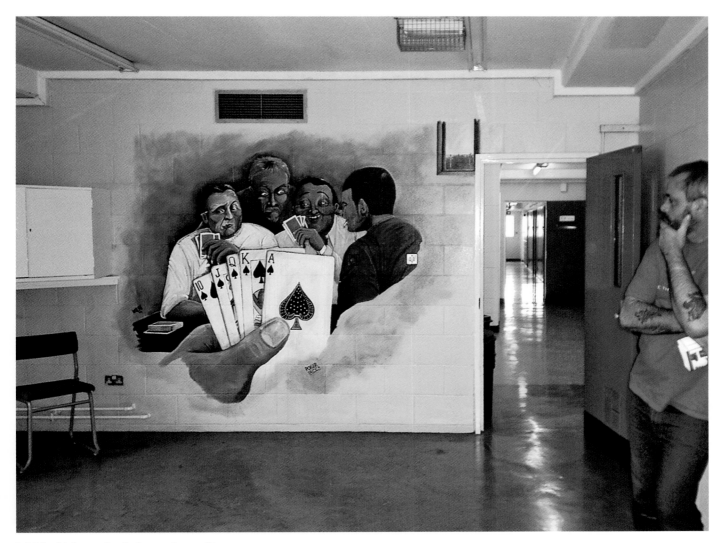

Wolfie Bishop, *Card players 2*, acrylic.

few days later mentioned what he'd said to a D wing officer who told me that he knew who that would be: a prisoner who up until a month or so earlier had been troublesome but for no apparent reason seemed to have changed his ways. I have no idea if it was just a coincidence but like to think not, if artwork can do that for one man it makes it all worthwhile.

Officers give him catalogues to order art materials from, and pay for his materials. He tends to use acrylics, applying a protective glaze afterwards. He also does some work on commission for both inmates and officers, though less now than he used to. He keeps his prices low for inmates – an ounce of tobacco for a portrait. He has also exhibited and sold work at prison art exhibitions, and gained some prizes in the process.

Wolfie's *chef d'oeuvre* is his triptych across a wall of his houseblock's Association Room:

My initial idea was to invite fellow inmates to turn their chairs to face the wall and lose themselves in the painting. To achieve this, I wanted to create something they could all relate to, offer something we all have in common, a future. Which future is a

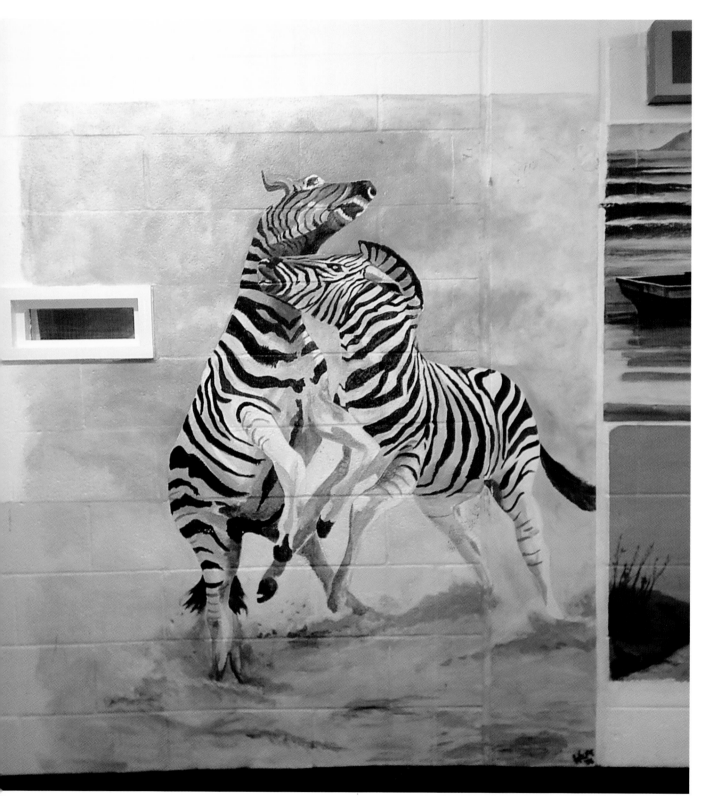

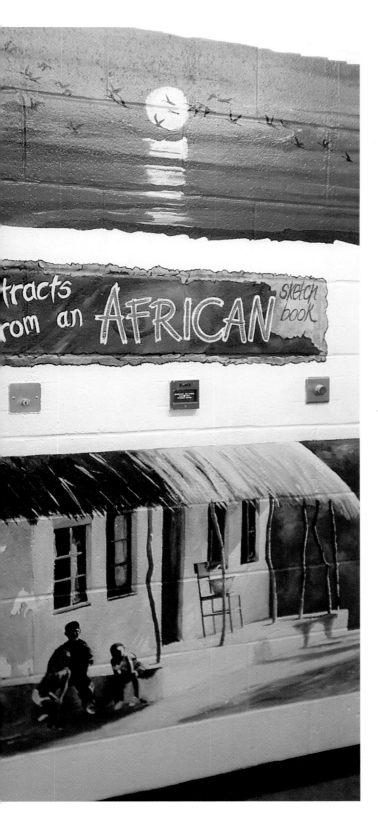

choice for the individual so I gave them three options of my own: peace and relaxation on the left, something a bit dangerous, on the edge, in the middle which became another talking point on its own merit. 'Is the man just watching the world go by?' or, 'Is he depressed and ready to top himself?' or, 'Maybe he's in a hard-working settled job and is merely taking his lunch-break.' These were common questions and observations made. At least they're thinking about things, and I know a few who were inspired by that to go away and sketch the landscape from their windows. Finally there is the option of religion which many turn to whilst inside.

I didn't get crowds gallery-style but everyone that saw it stopped and studied it, read the message, made mainly good comments and left. I had excellent feedback from most and still do six months later.

Wolfie hopes to do art at college on release.

NOTES

1 HMP Dovegate is a privately-run prison operated by Serco. It has a purpose-built therapeutic community (one of two in the UK), a 200-bed unit for repeat serious offenders. Residents do daily group therapy and have a say in how the unit is run.

far left and left: Wolfie Bishop, *Extracts from an African Sketchbook,* acrylic.

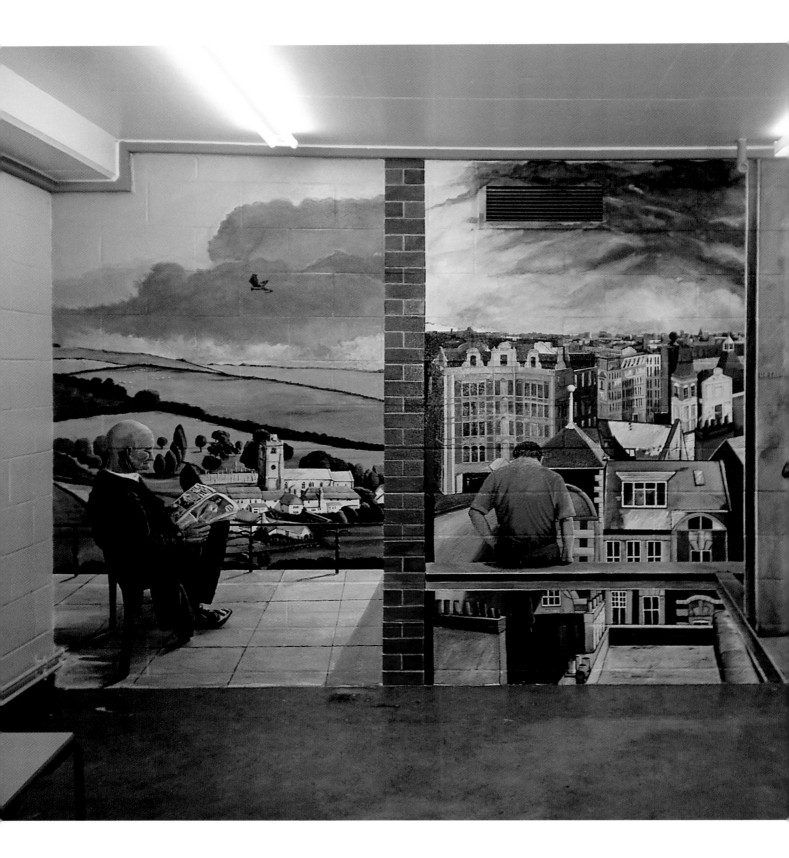

left and above: Wolfie Bishop, *Tryptich* and detail, acrylic.

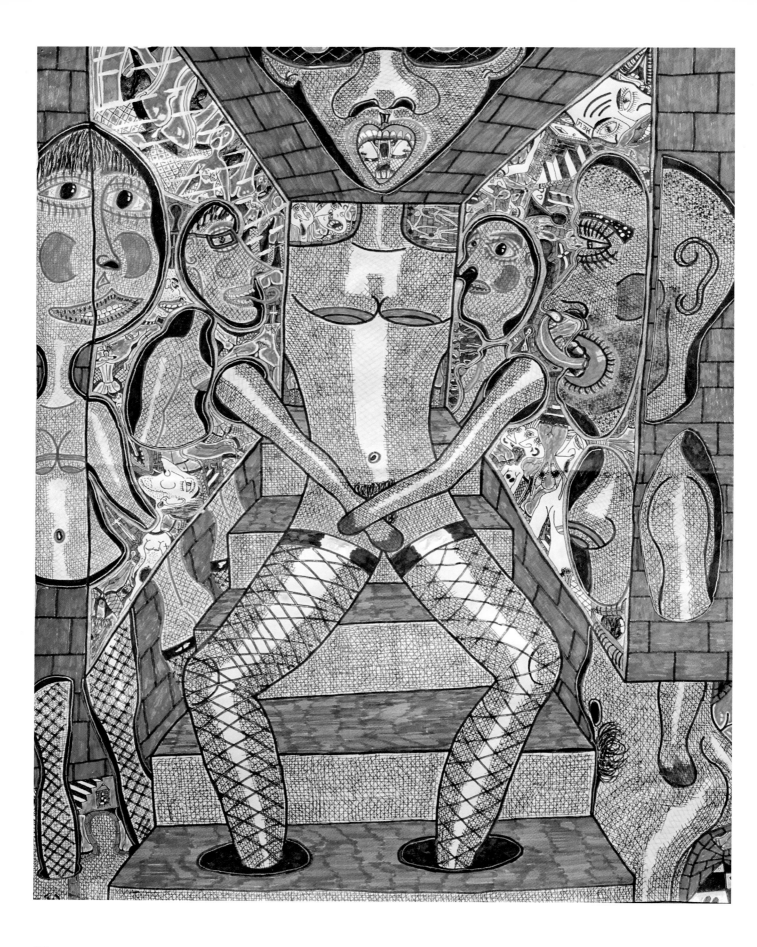

90

6 Horror Vacui

Some of the most compelling art produced across the wide spectrum of closed institutions in the criminal justice system is made in special hospitals: Ashworth, Broadmoor and Rampton. These are high security closed NHS institutions holding 'mentally disordered' offenders. Three categories of patient are detained, some indefinitely: the mentally ill or psychotic, those with personality disorders, and those with learning disabilities. Patients can be sentenced directly to these hospitals (and other Forensic Services establishments), others are referred from other NHS psychiatric hospitals, and a large proportion come from prisons, where their mental health has deteriorated. Rampton Hospital also accommodates dangerous offenders, particularly those with personality disorders, in the recently opened Peaks Unit. All three special hospitals have in the past been subject to calls for closure following inquiries into the ill-treatment and deaths of patients. Conditions have improved since, and nowadays patients take part in therapeutic programmes which are tailored according to specific need.

Art made by the mentally ill has been exhibited since the early 20th century. When first shown to the public it was called 'psychotic art'. This was because those who made it suffered from psychoses, or severely mood-altering mental states. Many of these artists had been designated 'criminally insane', and sometimes detained indefinitely in asylums. If given access to art materials by an enlightened superintendent, they might find a creative vocation. These images, although initially seen as primitive and child-like, were acknowledged as having artistic value and their imaginative qualities thought to reveal insights into the nature of the creative impulse.

Contemporary European artists, looking for fresh forms of expression, were also attracted to and influenced by these same qualities, and as the idea that art forms outside the cultural mainstream could have important or equal value developed, an identity for these artistic creators began to emerge. Excluded from cultural institutions by circumstances of birth, gender, race,

opposite: Sebastian Wilbur, *On the Steps*, A-level coursework, felt-tips, biro, mixed media.

education or mental health, they mostly had no formal art training, so their work lacked 'art' references and conventions and often used ordinary or discarded materials. Most commonly, they shared an inner compulsion to create a visionary scheme, realised in isolated or obscure circumstances.

When the Swiss psychiatrist Walter Morgenthaler published a monograph about his patient Adolf Wölfli in 1921, these qualities seemed compounded in the remarkable artistic identity of a man described recently as 'the quintessential outsider artist', (Rhodes, 2000). After serving two prison sentences for sex offences, Wölfli had been detained for life in the secure institution in Switzerland where Morgenthaler worked. He encouraged Wölfli's creative activities, which seemed to give respite from occasional and sometimes violent psychotic episodes. Over time he developed a compensatory world of delusory grandeur depicted in thousands of drawings of rich inventiveness. Morgenthaler was moved to write a book in which he revealed Wölfli's complex and visionary graphic work, whose characteristics have come to exemplify what became known as the 'Art of The Insane'. Most significant of these was what Morgenthaler called Wölfli's *horror vacui*, an intolerance of any blank space in a composition as expressed by the dense and decorative filling up of all areas of the surface. Shortly afterwards psychiatrist and art historian Hans Prinzhorn also identified these qualities in art produced by mental patients

detained in Swiss asylums, and in his influential book *Artistry of The Mentally Ill* he presented and analysed their work. Several of these had been in prison before being detained in psychiatric institutions.

Since discovered and promoted, 'psychotic art' has laid the foundations for Outsider Art and defined its core values. André Breton and Jean Dubuffet – Outsider Art's founder and gatekeeper – believed that madness provided conditions for the purest and most elemental expression of creativity, ideally produced by 'unacculturated' individuals in unsupervised circumstances, in which the disturbed imagination could express itself more freely. Today art made by patients in florid or psychotic states continues to be more attractive to museums, galleries and collectors, and is still referred to by connoisseurs and historians of Outsider Art as the Art of The Insane. In the changing face of modern psychiatry Dubuffet warned that its treatments developed for psychoses and other mental illnesses – medication, as well as other more brutal and invasive procedures – would suppress patients' creativity. He argued too that art therapy's paramedical and directive role would be fatally inhibiting. Morgenthaler and Prinzhorn's era came to be known as The Golden Age of Psychotic Art, and work by such artists is highly valued.

Perhaps because therapeutic and drug regimes have since been liberalised, over recent years some patients detained in special hospitals have been encouraged to develop individual

styles of artistic expression, and part of this work's attraction is undoubtedly its direct and uncensored content. Interesting art has been done by patients at Rampton Special Hospital; Alison Wickstead has run art classes there for 22 years. I hoped to find out how she worked with the patients there, although I would be unable to meet any of them or photograph their work. Ultimately I found out very little; perhaps her commendably protective habit of discretion regarding patients' identities made this inevitable. Formerly the Institute for the Criminally Insane, Rampton was built a century ago to accommodate Broadmoor's overflow. Its 400 patients live behind double rows of razor-wire topped, high perimeter mesh fences, fronted by an 1980s estate housing some of their 1700 staff. After an airport-style security screening, Alison collected me from the waiting area.

We talked in her office about her work with patients, some of whom have been there much longer than her. In 2005 classes were segregated, and Alison now runs the men's classes. Whilst we talked she showed me a Power Point presentation of Men's Art to be shown in the male patients' recreation area. This would help celebrate Men's Health Day, a nation-wide NHS event. Much of the work was vividly self-expressive and used a wide range of media and materials. Confident and individual styles seemed to suggest a relatively hands-off approach, so I was surprised to discover that some of this was academic course work (see p.90). Alison explained: 'It is important that

Sebastian Wilbur, *Confusion of parts,* felt-tips, biro, mixed media.

success is valued. I began to realise that the patients I'd seen over the last few years could do art examinations.' I wondered whether these curricular requirements might restrict patients' freedom of individual expression, but I realised these pressures had no meaning in Alison's patient-centred approach – in contrast to prison Education Departments, where funding and resources can be dependent on exam pass rates. Her priorities were different: hospital art workers are part of core staff teams, and patients' art is submitted at care planning conferences. Subsequently her work had been reasonably resourced, although Dubuffet would not have approved of her approach; embedded into modern psychiatric practice, its socialising ethos precluded most of his conditions for the production of authentic Outsider Art, notably

physical and cultural isolation and, crucially, non-supervision.

For many years this work could only be seen at the annual Koestler Awards exhibition, but recently artist and writer John Holt has established AIM (Artists in Mind), a charity based in Huddersfield which supports artists coping with acute and

enduring mental health problems. Many of these have come from prison, secure hospitals (notably Rampton), and forensic units. AIM provides these artists with studios and exhibiting opportunities and is developing an archive of their work.

As elsewhere in the criminal justice system, the annual Koestler exhibition has been a validation of such patients' artistic and rehabilitative achievement. For artists from Rampton it has remained an important showcase, though hospital authorities are keen to protect patients' identities: their work is exhibited under

above left: Sebastian Wilbur, *Facial Gateway,* felt-tips, biro, mixed media.
right: Sebastian Wilbur, *Hands on,* felt-tips, biro, mixed media.
opposite: Sebastian Wilbur, *Nothing to Hide,* felt-tips, biro, mixed media.

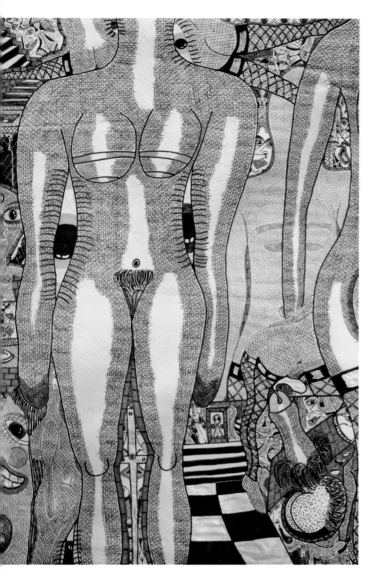

their share of serial killers and other red-top horror figures (as found in tabloid newspapers). In more innocent times when patients' work was sold, Alison made sure it was for a reasonable amount: 'It was partly my fault the prices went up, it's important that the patients' work is valued.'

Sebastian Wilbur was one of Alison's patients for nine years. First sectioned 15 years ago, he is now resident in the psychiatric unit of a London hospital, where I went to meet him. He was allowed out twice a week for up to two hours on his own, though for longer trips such as visiting his mother he had to be escorted, and I was reminded that despite his apparent independence he was still detained in a secure Forensic Services setting. He hoped that later that year he would be able to make these trips alone, but was phlegmatic: after 15 years in special hospitals and secure units optimism didn't come easily.

I wanted to talk with Sebastian about his art, which I had admired for several years. He has developed a dense, graphic style with its own symbolic language, sharing the *horror vacui* of others working in similar circumstances, 'outsider' artists such as Johann Hauser and Martin Ramirez. Wilbur though had enjoyed studying the work of artists he'd come across whilst doing accredited coursework, and happily acknowledged their influence. This exposure to other people's art inspired him but didn't seem to have affected his style. Ex-prisoner artist Peter Cameron believes that even the imprisoned artist has too much 'knowingness', exposed and

pseudonyms, and some years submissions to the Awards scheme have been prevented altogether. Sales are now banned, at least for the time being. Alison explained that 'they can no longer sell their work because we can't be sure of the provenance of the buyer. We couldn't prove anything, but it has been quite a coincidence that work of indifferent quality by notorious criminals has been sold.' That this might happen on the scale of 'death row art' in America is unlikely, though it seems the prospect alarms the authorities, and certainly special hospitals house

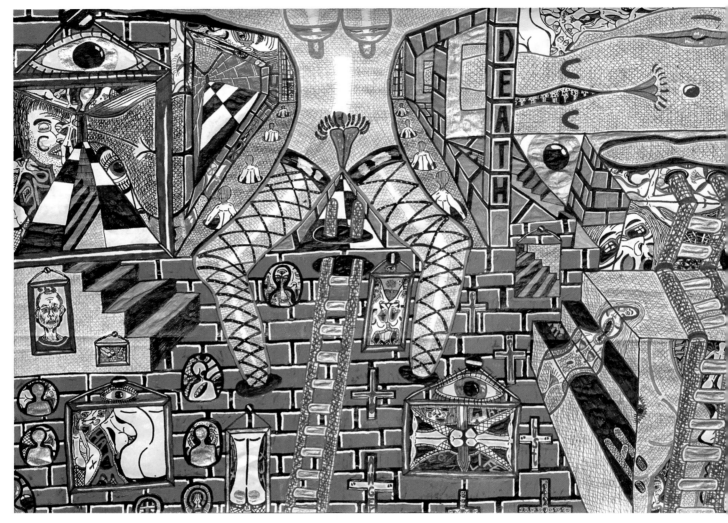

Sebastian Wilbur, *Pictures within pictures*, felt-tips, biro, mixed media.

educated by art class, prison library or in-cell TV with its stream of art programmes, to lay claim to a genuinely naïve vision. But Wilbur himself suggested that despite this exposure, constant validation from Alison Wickstead, John Holt and others had helped confirm his style: 'The feedback I got was so strong it really egged me on.'

We met at a café for lunch near the hospital, and he told me how he had become an artist. He had spent three years at Kneesworth House

Hospital, Cambridge, on a heavy drug regime before moving to Rampton, and when he arrived he had had trouble communicating with anyone – 'I really couldn't talk at all when I got there, but things really picked up'. Doctors suggested he try art therapy, and he found he could express his feelings through art. In turn his art gave him the fluency and confidence to communicate with people. Perhaps this explains the attraction of his work: its explicit

iconography describes his feelings of exclusion and isolation so vividly. This exposition was particularly valued in a therapeutic environment where emotional literacy and social reintegration were measures of the recovery of mental health.

Alison Wickstead was central in all this support, and when she encouraged him to try accredited courses he found that he enjoyed the structure and progress of academic work: 'I was just motoring along – I'd be doing basic exams, there'd be a course to follow, I'd look up famous artists like Dali and Picasso and they'd influence me.' Getting awards and recognition from the Koestler Trust had also helped keep him going, although not being able to sell work had been a frustration.

When he left Rampton, Sebastian was initially prevented from taking his work out. 'They claimed that because the materials belonged to them I couldn't take my work with me. Alison fought tooth and nail.'

Sebastian continues to make art, both in hospital and at a local art centre:

It's never-ending, it's like I'm doing it now. I like to chop and change: the pen and ink ones – they're done over several stages. I'll do some large pencil drawings, then do something else, like pastel portraits of celebrities. I'm doing more 3D work at the moment, working with clay. Sometimes months later I'll go back to the drawings and fill them in or change them.

He talked unprompted about the often explicit and graphic content of his work. It features a riveting mix of pierced bodies, splayed limbs, brick walls, ladders leading into open thighs, buttocks, breasts, vaginas, penises, crosses, daggers, as well as Sebastian's own bewildered bespectacled face looking out; areas all worked in strong outlines and cross-hatching with biro, felt-tips, pencil and anything else to hand.

As for their iconography: I made symbols to express and communicate my feelings. There was quite a lot of genitalia. This is because I don't understand relationships, what happens between men and women. As for the brick walls, they express the closed-off environment I was in for so long, the fact that I couldn't go anywhere. The crosses are obvious, they represent my suffering, and as for the eyes, also the faceless figures, they both represented my paranoia, just feeling watched and observed all the time, particularly in hospital.

In fact as the ubiquitous door spy-hole attests, psychiatric patients and prisoners really are under constant observation.

He feels more hopeful about his future art career, bolstered by the enthusiasm and encouragement of those who have helped nurture his vocation, though this seems prey to uncertainties. As his world opens up, his forward path seems unclear beyond the diminishing security of ward and art room. He's both keen to go to art school and exhibit his work, but apprehensive too, aware perhaps that its character and context will

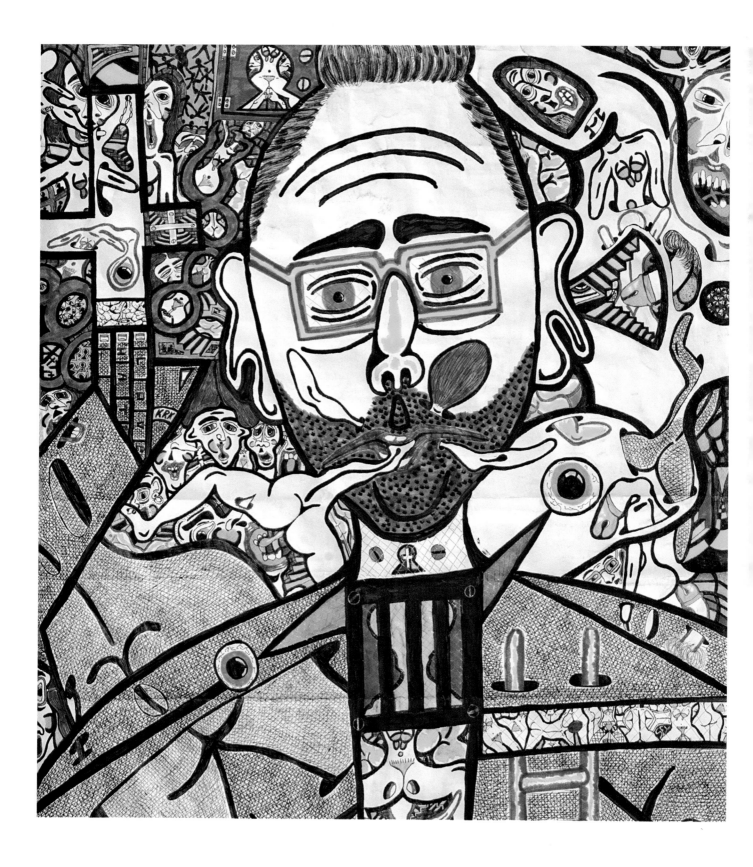

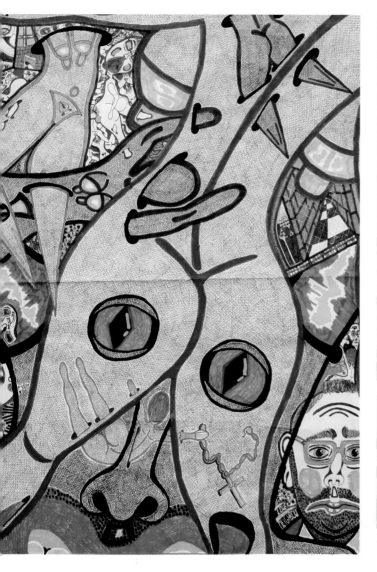

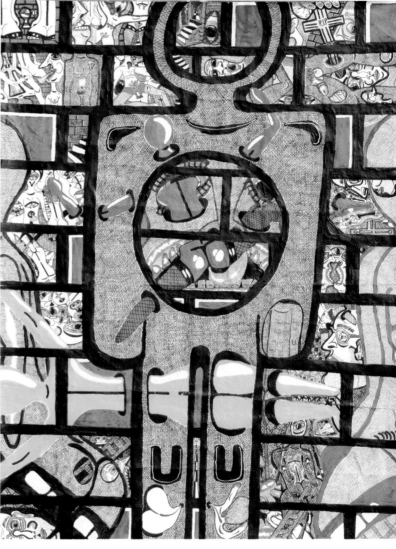

not only determine its reception but could limit future opportunities, a professional dilemma facing many whose creative vocations were formed inside. Before he returned to his ward

Sebastian asked me: 'Have you travelled much? I have never been abroad.' He seems unsure as to whether he will ever be able to.

opposite: Sebastian Wilbur, *Stairways to Heaven,* felt-tips, biro, mixed media.
above left: Sebastian Wilbur, *The Devil Behind,* felt-tips, biro, mixed media.

above right: Sebastian Wilbur, *Wall of life,* felt-tips, biro, mixed media.

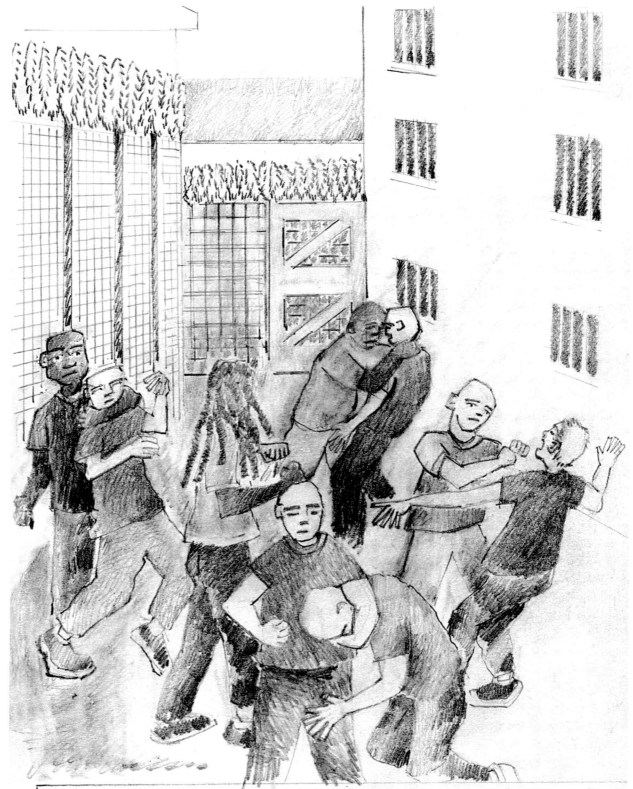

THE FIGHT DIDN'T LAST LONG, THE PIKEYS GOT HAMMERED. IT WAS
NOVEMBER 2006. FOREST BANK PRISON WAS ON LOCKDOWN, IN THOSE
DAYS YOU HAD TO BE A REAL MAN, KEEPING IT REAL, AND SURVIVING
ON WING D2. JUSTICE WAS A DREAM, BUT ONE THAT I CONTINUED TO LIVE FOR

7
Graphic Art & Graffiti

If street art has come in from the ghetto, why are graffiti artists still going to prison? For some time now street artists of all stripes have been welcome in museums and galleries, giving curators a populist opportunity to connect with the edgier slice of their urban demographic.

Recently both Tate Modern's Street Art exhibition and Banksy's retrospective in Bristol along with the burgeoning growth of official graffiti walls have all amounted to official cultural endorsement, but for any self-respecting graffiti crew it's just not the same as breaking

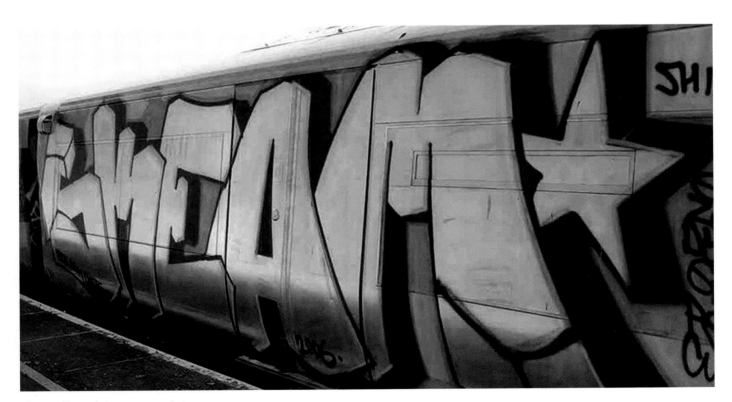

above: *Skeam's tag*, spraypaint.
opposite: David Langdon, *Yardie 2*, pencil.

Graffiti artist gang jailed for six years

A GANG of graffiti artists who caused £70,000 of damage to Tube trains were jailed for a total of six years yesterday. Six members of Australian Mother F*****s tagged the capital's trains so others could admire their work. One, 22-year-old Adrian Hing, went 'decorating' the day he came to Britain. 'Each of you are intelligent men and talented artists,' Judge Michael Gledhill told them at Southwark Crown Court. 'To see you in the dock facing a custodial sentence is quite appalling.' Hing, with three more men from Dalston and two of Bromley-by-Bow, east London, admitted criminal damage. Judge Gledhill added: 'Those who become involved in graffiti must face a custodial sentence.'

Graffiti artist gang jailed for 6 years, newspaper cutting.

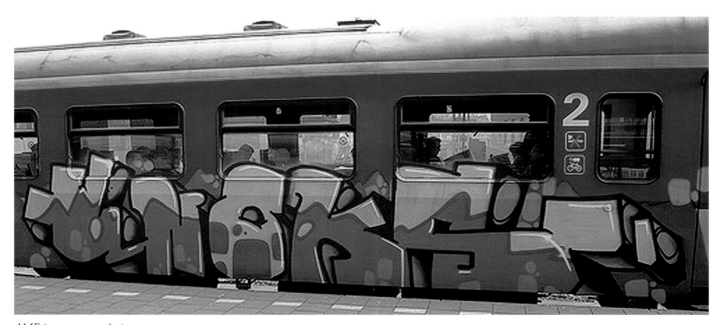

AMF tag, spraypaint.

into a train marshalling yard and tagging the rolling stock.

On St. Valentine's Day 2009 protesters gathered in central London to demonstrate against sending graffiti artists to prison, prompted by the suicide of 'Skeam', the tag name of a young graffiti artist who had been given a 30-month custodial sentence. He had been transferred from HMP Wandsworth to HMP Camphill on the Isle of Wight, but hated the prison and its regime. After a successful appeal in which his sentence was reduced to 10 months he had hoped to finish his sentence at Wandsworth, but was returned instead to Camphill, where he hanged himself.

He and another three members of the Just Kant Stop and the Forever Doing Crime graffiti crews had received sentences totalling more than six years.[1] Many have questioned the harsh sentencing for graffiti offences, as well as the high figures (£60–£70,000) quoted for criminal damage costs by the British Transport Police.

Back in HMP Wandsworth, another graffiti crew was sentenced in the Spring of 2009 to serve between eight and 12 months in prison. The six-strong AMF (Australian Mother Fuckers) crew achieved worldwide notoriety after 'bombing' trains (covering them with graffiti) in East London marshalling yards. They were three days into a five-week holiday tour of Europe when arrested, and will be deported once they have served their sentences, with the exception of two who have British passports and will be allowed to stay. In the meantime they attend daily art classes in the prison education department's portakabin: some practise their tags, one is learning landscape painting in acrylics, another is busy making greetings cards for other prisoners on his landing. These are beautifully made, with carefully engineered moving paper parts. Adrian charges half an ounce of Golden Virginia tobacco per card. He doesn't smoke himself, but 'burn' is prison's universal currency and he can trade for items he needs from the canteen. Normally commercial activity of this kind isn't tolerated in the art class, but the young Australians are well-liked by prison staff and inmates, and they will be out on parole in a few weeks anyway.

Mostly this kind of art takes place outside the education department art room alongside the more traditional kinds of graphic art made in prisons such as portraits, cartoons, illustrative art of various kinds; its value is set by prisons' bartering economies, its life usually ephemeral. From half an ounce of Golden Virginia upwards, portraits can provide a useful income, but those with more serious creative intent usually give it up, finding customers' demands constrictive and time-consuming.[2]

David Langdon

Whilst imprisoned in HMP Forest Bank David Langdon used his skills as a professional comic book artist and illustrator to record his time there. As well as making more personal observations of prison life he wrote and

illustrated the Forest Bank Visual Diaries, describing his attempts to pursue his case at the European Court of Human Rights. In them he argues that visual language has equal legal status with verbal language, and likens his satirical

far left: David Langdon, *Cell 2*, pencil.
left: David Langdon, *Cell 3*, pencil.
below: David Langdon, *Association*, pencil.

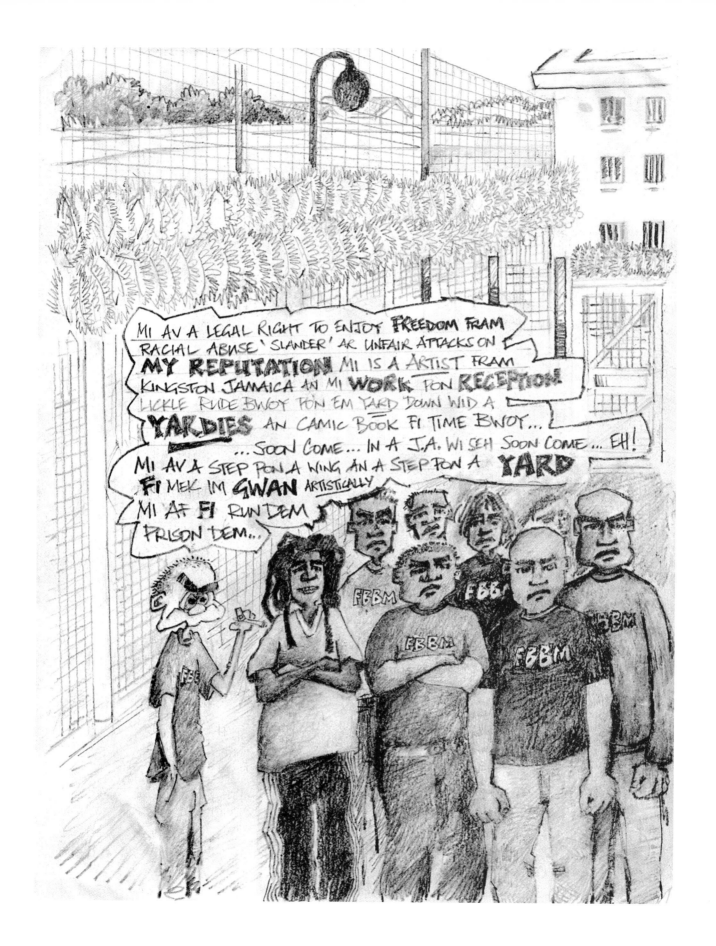

caricatures of court procedure to those of 19th century French artist Honore Daumier who served a six-month prison sentence for lampooning lawyers.

David relaxed his litigious zeal to chronicle events at Forest Bank in semi-fictional comic books. These were photocopied and circulated throughout the prison. *Yardie* tells the story of the showdown between two rival gangs, the Pikeys and the Yardies, who were led by 'Reggae Legend Prince Chisel' (see also p.100).

David was eventually moved to a secure mental health clinic suffering from depression, though has since been released.

Notes

1 As a result of recently enacted anti-terrorist legislation graffiti artists can be prosecuted together on conspiracy charges.

2 For further information on this subject – blogs, forum and gallery – see 12ozProphet.com

opposite David Langdon, *Yardies*, Pencil.

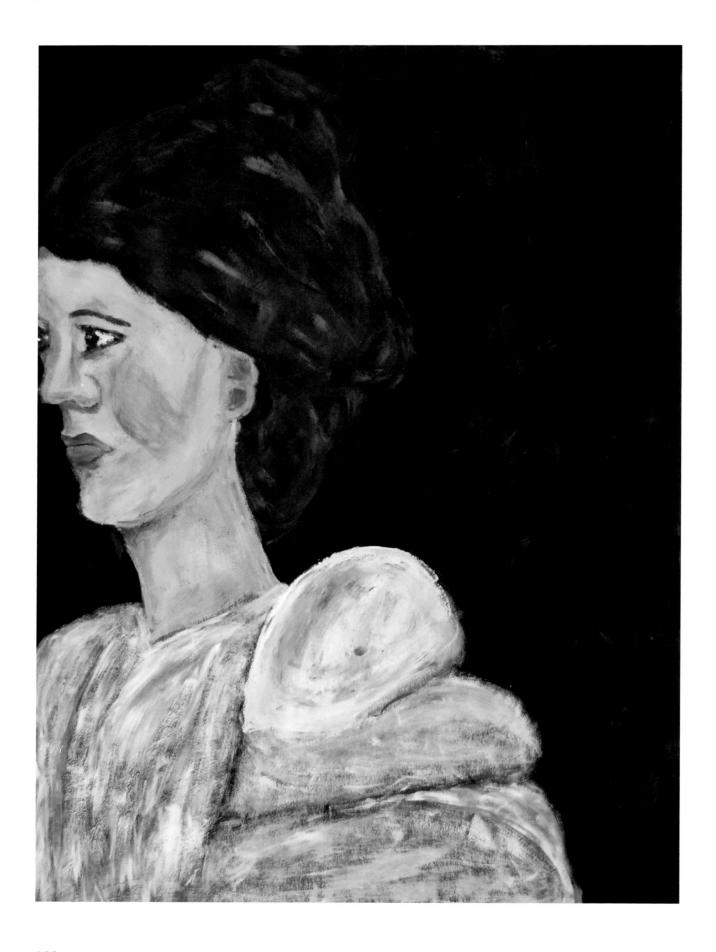

8

Artists Inside and Out

INSIDE

CLARE BARSTOW

When convictions are successfully challenged, such miscarriages of justice – particularly if lengthy sentences have already been served – get headlines. These cases, many well-known, are too numerous to recount. In the meantime campaigners continue to protest the innocence of other serving prisoners whose convictions they believe to be unsafe. These too are numerous, and Clare Barstow is one such, presently serving a life sentence. Campaigners say she was wrongfully convicted, and are fighting for her release. She herself has stated that she 'will carry on fighting my case until my name has been cleared and will not accept parole if offered it'. Once a working journalist, Clare also contributes to campaigns for the overturn of convictions of other women prisoners.[1] As well as articles she also writes more creatively,[2] saying 'writing has enabled me to cope more easily with all the traumas of prison life and has given me new-found inspiration in other areas of creativity'.

Clare Barstow, *Portrait*, acrylic.

Clare seems as accomplished an artist as she is a writer. Although she only started doing art after being sentenced, she had always enjoyed it, and went to lots of exhibitions and museums as a child. Her artwork has progressed whilst at three successive prisons, gaining all available qualifications along the way. She particularly valued the art teacher at HMP Cookham Wood, where she painted a mural, though when this prison was re-roled as a YOI in 2007, she was transferred to HMP Send. During her short time there she has been remarkably productive. Working in oils or acrylic, she has developed an expressive, figurative style. In 2008 the nearby Watts Gallery started an ongoing association with Send prison through its outreach programme, entitled the Big Issues project. The gallery funded artist in residence Sandy Curry who has continued to work there – like Clare, her own work is informed by social concern. Clare and other women she has worked with were asked to respond to paintings by G.F. Watts, and much of this work

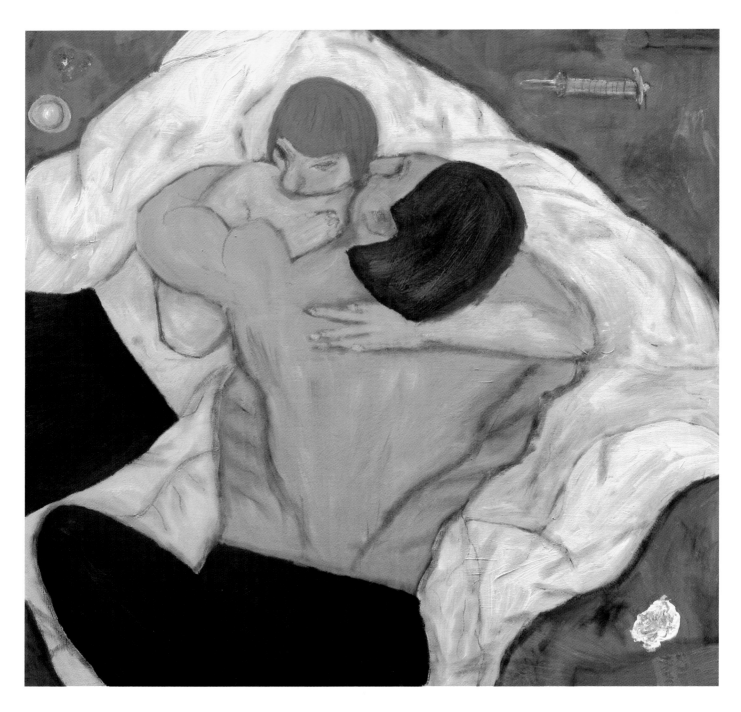

was exhibited at the Royal Society of Arts. This literary approach suited Clare well, giving full rein to her strong sense of social injustice. She painted *Love in the Time of Homelessness* inspired by Watts's *Under a Dry Arch,* a scene from his symbolic cycle *The House of Life.* Clare wrote that her painting 'tries to show that despite all the hardships of living on the streets, there is always hope, love and friendship to be found. It shows that amongst the detritus of poverty and abuse, warmth and love can offer support to the frightened and neglected.'[3]

Clare's portraits reflect the multicultural

above: Clare Barstow, *Love in the Time of Homelessness,* acrylic.
opposite: Clare Barstow, *Vision of the future,* acrylic.

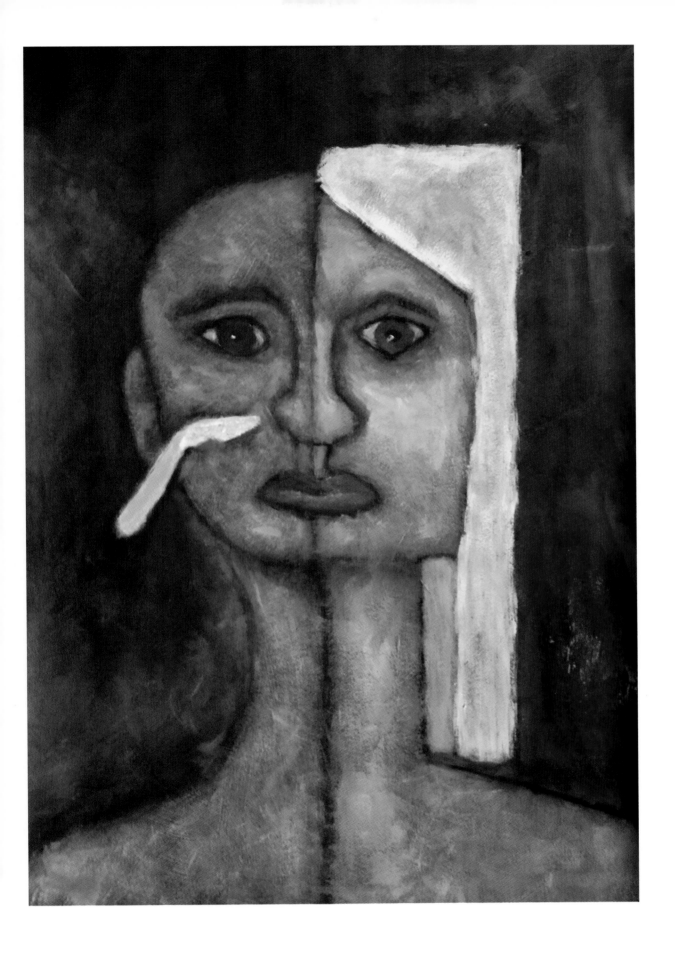

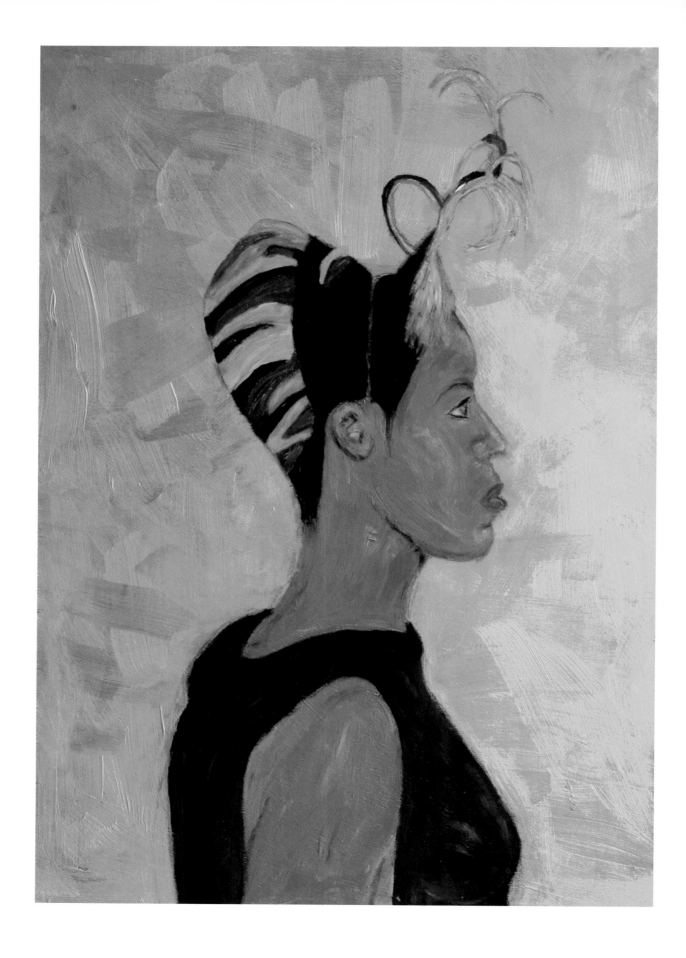

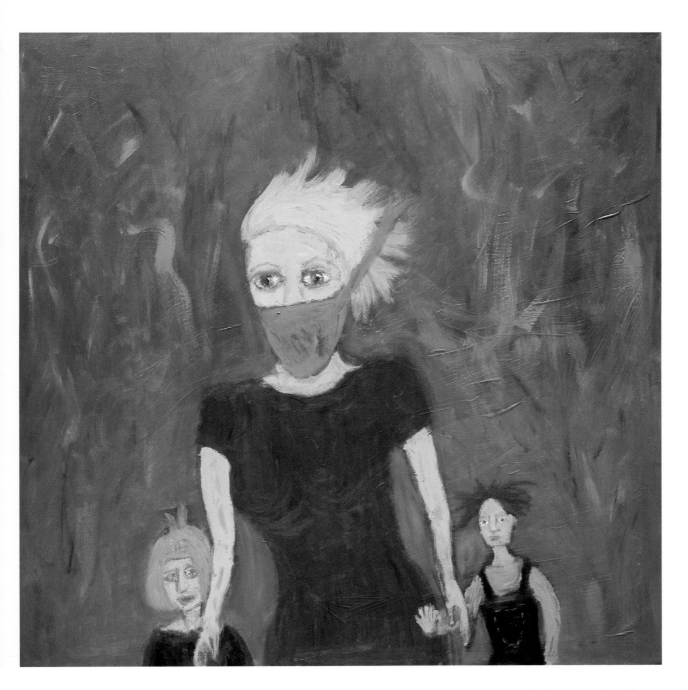

nature of prison life.

In *Individuality* she writes that: 'This painting depicts an African woman who is not scared to show her individuality and be proud of her cultural heritage in a society which works on the mechanisation of conformity. It also shows that colour enhances us and shape and style transforms us, gives us confidence and shouts out individuality and independence.' Perhaps Clare's depictions of strong, independent women come partly from her own experience of an abusive relationship and her subsequent need for self-reliance. In *Suffocation, Fear and Rejection* Clare shows 'a woman running with her two children from a violent relationship, the emotional affect

left: Clare Barstow, *Individuality*, oil.
above: Clare Barstow, *Suffocation, Fear and Rejection*, acrylic.

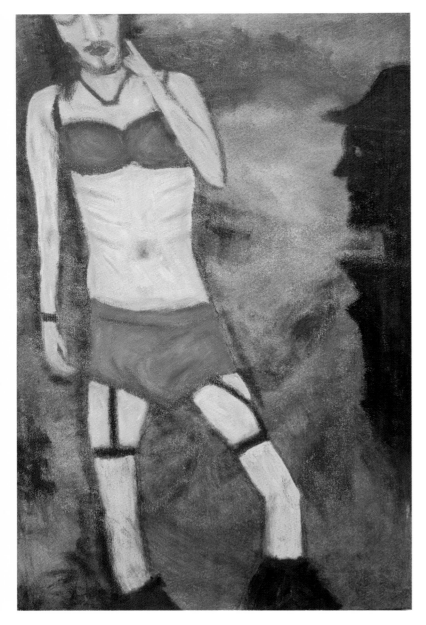

it has had on them and the conflagration shows the burning pain left behind'. She writes that the three characters 'symbolise each emotion and attempt to demonstrate the powerful effects of abuse and neglect in modern society'. Clare made her picture in response to Watts's sentimental and portentous *Time, Death and Judgement.* Unlike Watts's, her painting is an urgent and personal image, the mother's red face mask expressing censorship as well as fear of contagion.

Her more recent *Censorship* was inspired by the Jonathan Ross and Russell Brand prank phone call affair, and the *Daily Mail*'s melo-dramatic judgement. She has shown a burlesque Russell Brand posing for the disapproving silhouettes of *Daily Mail* readers. Clare continues to paint and write about subjects she feels passionately about, protesting and campaigning as she has always done.

left: Clare Barstow, *Censorship*, acrylic.
opposite: David Chartens, *Railway Carriage*, acrylic.

DAVID CHARTENS

After a brief spell of freedom David Chartens was recently returned to the prison where he became an artist. He is continuing with his *magnum opus,* a series of paintings about the RMS Titanic. His obsession goes back a long way: in 1958, when David was ten years old, he saw Roy Ward Baker's disaster movie *A Night to Remember*, starring Kenneth More. It made a huge impression and since then he has learnt everything he can about the *RMS Titanic*. But he dates his life as an artist from meeting Ivor, the tutor in charge of his prison art class. Ivor provided David with detailed instruction on composition and technique – such as how to paint reflected light on waves, building effects up in stages. He learned to work with acrylic, treating it like watercolour, laying down layers then blotting off to get the right effect. Finding a successful approach to this subject in particular – rendering the surface and depth of

water – has been central to David's project and his biggest challenge.

Prison was his creative crucible. With virtually no reference material, he did more than 40 paintings and many drawings showing all stages of the ship's voyage in knowledgeable detail. A passenger arrives on a London and South Western Railways boat train at Southampton dock. Through the window of a first class compartment the White Star Line's embarkation shed is visible, and alongside its quay the *Titanic* awaits. The ship can also be seen upside down, refracted through an abandoned carafe of water on the train compartment table, together with a menu, a brochure for the White Star Line's Transatlantic timetable and boat train

for the year 1912, and an empty coffee cup.

With Ivor's careful help and direction, and criticism from time to time, I embarked on a large picture of the Titanic approaching the iceberg. The picture pulled me into it – physically – I would be inside the section that I was working on. As I painted the bollards and sections of anchor chain on the foc'sle I would look up at the towering iceberg glinting at me as the blazing deck lights beneath the bridge reflected the diamond-like quality of the ice. As if to awake me from sleep, human voices would interrupt my voyage and make me aware that it was lunch, or

above: David Chartens, *Railway Carriage* (detail), acrylic.
right: David Chartens, *Impact,* acrylic.

time to sleep; the real world for me was completing the detail on the painting, not the day to day.

After 18 months David was transferred to another prison. Here he kept clear of Education and chose to work in his cell, refining his technique. David felt that the last thing he needed at this point was doing distracting still lifes and shading exercises. He decided to make a long biro drawing:

I had watched a television programme on art and took note of a concept of a photograph of painting set out in sections. When looked at from a distance the spaces in between disappeared and the total illustration came to the fore; along the lines of the Bayeux Tapestry. I noticed whilst working at my job, that at the top and bottom of a large box of tea bags, there was a parchment-like piece of re-cycled off-white paper. I began to collect these and to start a series of inter-connected drawings of the entire course of the Titanic's Maiden Voyage showing her, large and small, close up and afar, passing all the various milestones of that voyage. I ended up with 70 drawings, mounted on boards each with seven images, ten boards in all. They show the dock at Southampton, the Isle of Wight, Cherbourg, Queenstown, Fastnet Rock, out into the Atlantic and on to her brush with destiny and sinking. The entire drawing is 17.7m (58 ft) long and 30cm (12in) high.

The overall impression is of a storyboard, the ship reproduced several times on each panel like a comic strip.

Viewpoints in his paintings range from peaceful postcard calm to swooping seagull-like aerial perspective: when he returned to prison, a maths tutor in Education gave him advice on vanishing points. The resulting picture – *From the*

above: David Chartens, *Brush with destiny,* biro.
right: David Chartens, *Sandon Flying Club,* acrylic.

Flying Machine – is a pilot's view looking down at the *Titanic* as she skirts the Eastern tip of the Isle of Wight. Cattle graze in the fields alongside the shadow of the plane.

This and other earlier scenes from David's sequence of images give no hint of forthcoming doom, and we are distracted from our retrospective

left: David Chartens, *Going down,* acrylic.
above: David Chartens, *Arriving in New York*, acrylic.

knowledge by their busy and attractive detail. Only in the last frames of the story, as ship and iceberg eventually collide, does the personal nature of this disaster and its painful metaphor become clear (see p.120). But another scene shows the ship arriving in New York as if nothing had happened! Perhaps it suggests the possibility of David's survival, recovering from disaster: an alternative future (see above).

David has no interest yet in moving on to

David Chartens, *Impact,* acrylic.

other subjects.[4] Possibly he might, if he fulfils his greater ambition:

2012 is the hundredth anniversary of the sinking of the Titanic. As well as this it is the London venue for the Olympic Games. My goal in creating a large number of paintings of the voyage of the Titanic, from every angle and within sight of every notable landmark that it passed by on that fateful and only voyage, was in order to offer to the Post Office enough paintings to create a series of commemorative stamps for the Titanic's hundredth anniversary in 2112.

His schematic vision is all his own, and his art has the intense feel of the self-taught artist, despite his debt to Ivor. During his recent spell of freedom he was able to pursue his need for authentic sources, buying an 1876 issue of *The Illustrated London News* in Camden Market. The wood engraving on the cover shows one of the four Solent Forts, and was useful reference material for his next composition of the *Titanic,*

this time setting out at night from Southampton. He says his style is most influenced by the early 20th century illustrators of *The Illustrated London News*, *The Sphere* and *The Graphic*, though he's always liked marine painting, and singles out the artist Montague Black and his famous poster for the White Star shipping line advertising the Titanic's Atlantic voyage. And although he would dislike their artless charm, David's manifest of ships, harbours, and lighthouses recalls the memory paintings of mariner-turned-artist Alfred Wallis.

Most recently he has been recreating the marine painting *Plymouth Harbour* by Norman Wilkinson. This was especially commissioned for the *Titanic's* first class smoking room, and went down with the ship. David has been using photographs in which it appears in the background, as well as a surviving picture Wilkinson painted for the *Titanic's* sister ship *RMS Olympic* to get the colour right.

CURTIS ELTON

Curtis is a stocky man in his early 50s. Whilst on remand he had become known on his wing as 'the prof' on account of his Einstein-like hair, wire-rimmed glasses and clever, helpful personality.

It was unusual for prisoners to volunteer any information about their offence: some Education classes – social and life skills, or a creative 'life writing' group, required a degree of auto-biographical frankness from participants, but art students mostly just get on with it, absorbed in their work. It seemed that this man I had never met before needed to confess, a quality which gave his artwork as it developed a fascinating – to some, repelling – character. In the art room he

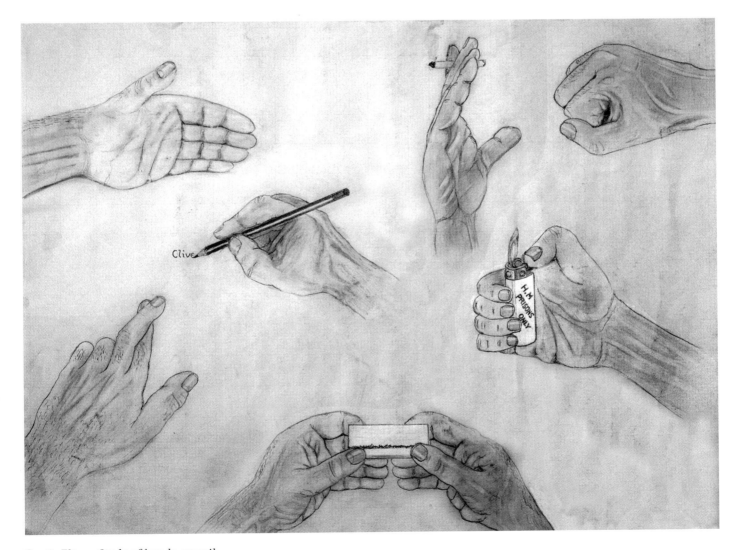

Curtis Elton, *Study of hands*, pencil.

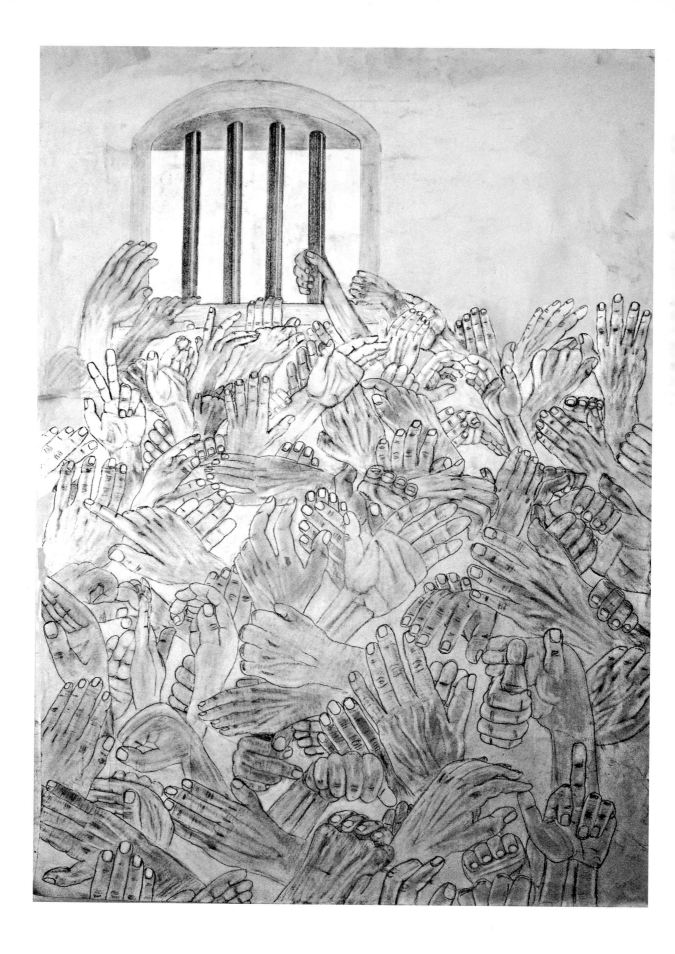

drawing. As he got more confident with his technique he could depict his personal mix of confession and defiance in explicit imagery. An early one showed Curtis peering out downtrodden beneath a woman's stockinged leg and stiletto heel (see left).

A year later he produced a fuller version of the same idea. It's not uncommon to find images of threateningly independent women in men's prison art, but these were further out, in dominatrix and dungeon territory, taking in serpents and other reptile-like transformations. This seemed to express some of the contradictory tension he felt, the need to reveal and conceal. These ideas merged naturally with classic prison motifs – bars, keys etc. which Curtis depicted in scenes of incarceration, set somewhere between Piranesi and Camp X-Ray.

Once sentenced, Curtis was transferred to a large Vulnerable Prisoner Unit in another prison. Curtis joined the art class and both there and in his cell continued to explore the same themes, still illustrating his sexual obsessions. Surrealist eyes and mouths start appearing, common enough motifs in prison art, referencing the watching eye and speaking mouth at the cell door's observation hole.

was friendly, enthusiastic, motivated and eager to learn. Tutors were keen to encourage his artistic appetite, and gave him sketchbooks which he soon filled up with drawings made in his cell: hand studies (see p.123), self-portraits, poignant still lifes from a Spartan cast of prisoner's possessions. Some of these studies found their way into bigger compositions, for example this drawing of dozens of groping hands reaching up to a high barred window, an uncomfortable and claustrophobic vision of helpless panic (see opposite).

Without directly describing his offence he found the means to express the traumatic impact imprisonment had had on his life, through

left: Curtis Elton, *Hands*, pencil.
above: Curtis Elton, *Stilettos,* pencil.

overleaf
left: Curtis Elton, *Downtrodden,* pencil.
right: Curtis Elton, *Serpent woman,* pencil.

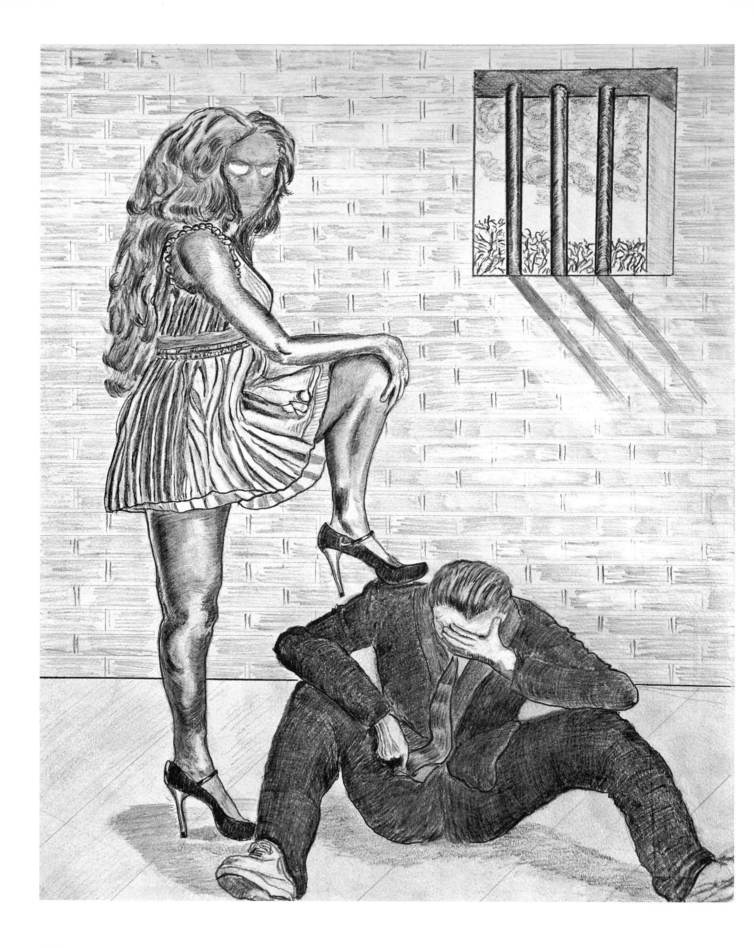

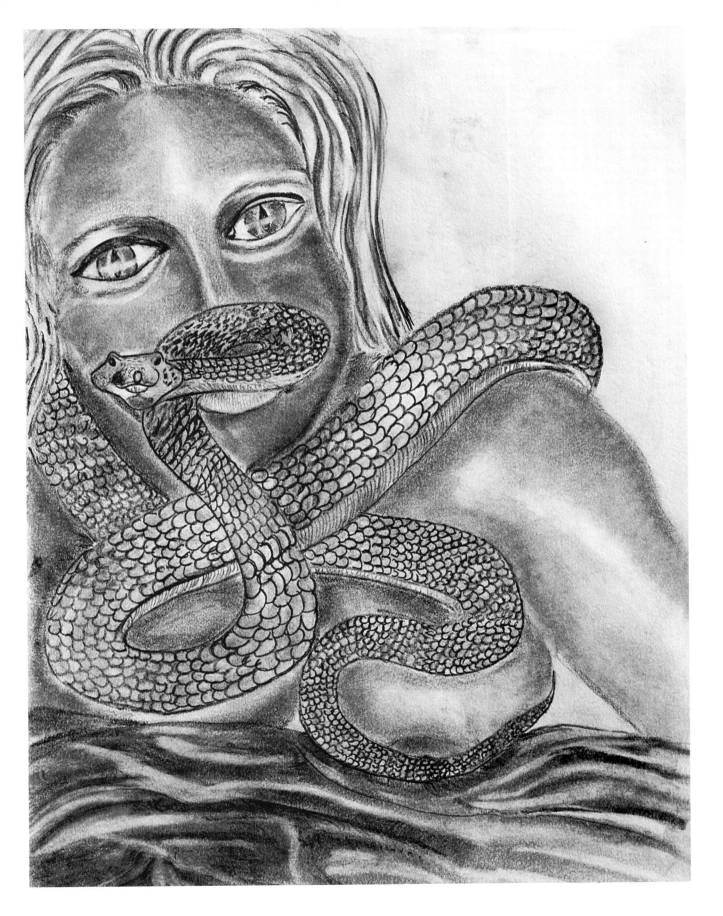

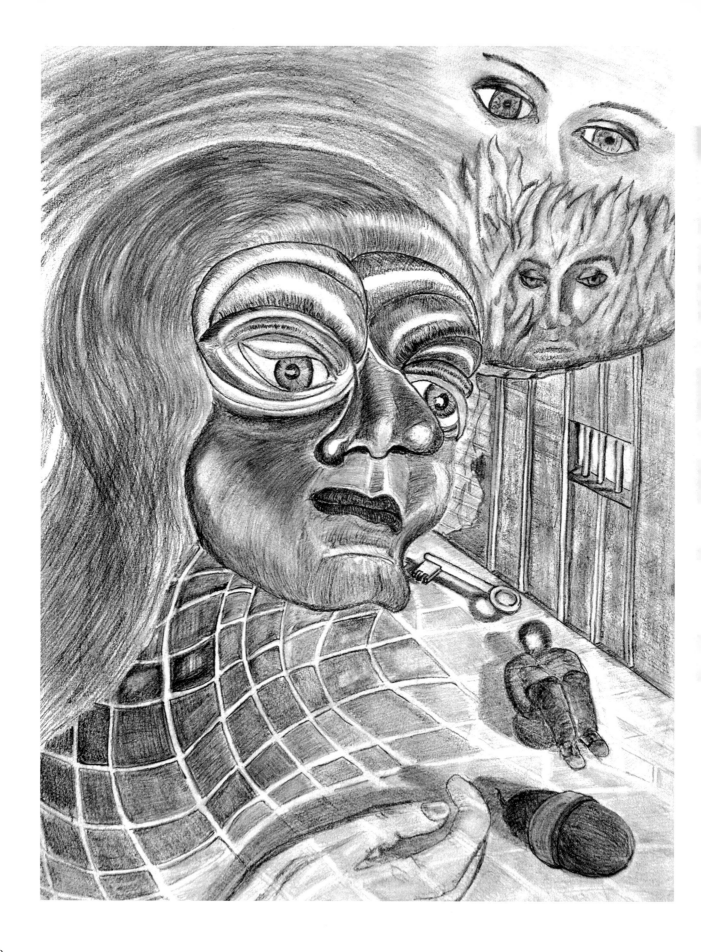

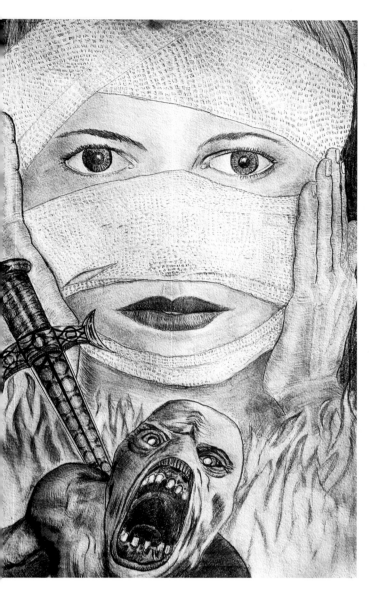

had managed to order from a large London art shop which gives discounts to purchases from serving inmates.[5] He had recently completed SOTP, the Sex Offenders' Treatment Programme, and seemed to have made the most of the opportunities it had provided for confession: 'I want to warn people, you can get sucked in ... there are subliminal messages on internet (porn) sites.'

The British criminal justice system has developed and pioneered the use of SOTP courses, and the national programme is the largest of its kind in the world. Based on cognitive behaviour therapy, they have proved effective in addressing and overcoming the justifications and denials which can keep sex offenders in prison for years past their sentence tariffs.[6] Curtis said it had worked for him, and that his artwork was now less explicit than before. He thought too that as his sense of self-worth improved the S & M theme so evident in his work would play itself out. The therapist seemed to be speaking here, but he had realised the need to adjust his boundaries, and that the role-play which had gone so badly wrong in the first place might find more modified expression in his art.

By now he'd had some success and recognition, getting Koestler Awards and finding his portrait skills in demand, though he soon got fed up with this. His family had tried unsuccessfully to bring in art materials for him, but he

Curtis has started working in Tailoring during the day, continuing his art at evening classes and weekends. Now painting in acrylics, he makes copies of figures which catch his eye in newspapers and magazines – but misses the intensity of his earlier graphic work.

One day he wants to open an art gallery in Sevenoaks.

left: Curtis Elton, *Remembering*, pencil.
above: Curtis Elton, *Betrayed*, pencil and conté.

above: Curtis Elton, *Pieta*, pencil.
far left: Curtis Elton, *Her tiger nail,* pencil and conté.

GARVEY THOMPSON

By the time I went to meet Garvey at HMP Risley he was already something of a *cause célèbre*. His art teacher Paula Keenan had first submitted his paintings to the annual Koestler Prison Art Awards scheme the previous year and their expressive impact had caused a stir, the Trust's director Tim Robertson describing him as 'one of our most talented entrants'. In his early 20s, Garvey was still taking in the impact his work had made:

When my teacher told me she was entering me in the competitions I thought it was pointless, because I did not think I could compete at that level – but I was very wrong. Then when she told me I had won numerous awards I was flabbergasted! I had never ever won anything in my whole life, and I was really overwhelmed by such recognition. Being recognised for something good in my life is very pleasing. At last my mum has something to be proud of me for.

Garvey was born and raised in Birmingham, left school early and got involved in gangland and petty crime. There wasn't any art at home and he didn't do any at school 'although I used to spend a lot of time drawing and doodling faces and figures from my imagination'. Faces and figures remain Garvey's *forte*, a vivid portrait gallery of characters presented full-face, painted

above right: Garvey Thompson, *Garvey with picture*, photo.
right: *Garvey with hat*, photo.
opposite above: Garvey Thompson, *Go*, acrylic.
below: Garvey Thompson, *Bright eyes*, acrylic.

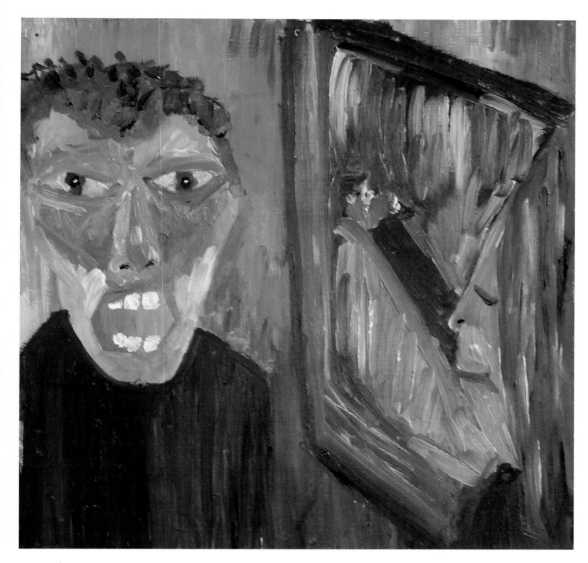

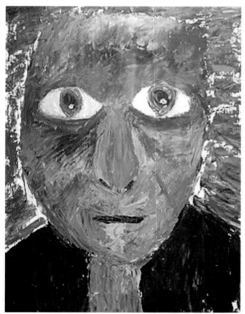

with visceral animation and confidence.

It was during Garvey's third sentence that his art took off. At a previous prison he had started going to art classes in Education, but found the coursework boring: he had to draw still lifes and wasn't allowed to paint on his own. Garvey didn't enjoy this and left the class after a month. 'Then when I came to Risley I decided to have another shot at art – I found it more relaxed and I could express myself a lot more in the art class. My art teacher helped me to develop my own style, taught me how to use other media and gave me confidence. I was encouraged by everyone in the education department at Risley.' And as his work progressed art teacher Paula brought officers and other teachers to look at it. She confirmed the impact

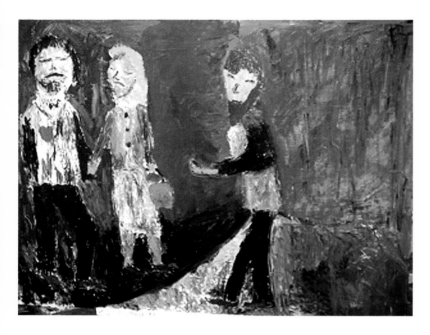

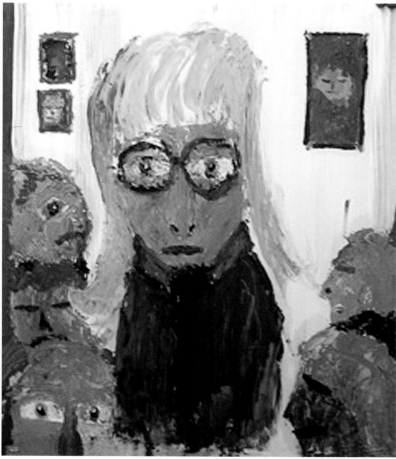

Garvey's work had on those who saw it: 'His work has earned him a lot of respect from his peers, and people have started to take art more seriously as a way of expressing themselves.'

Garvey worked with acrylic on card and hardboard, consuming large quantities of paint with his impasto style. Paula recalls that Garvey didn't want to look at the work of other artists, preferring to develop ideas on his own. He made early forays into mixed figure compositions but his preferred format became a central portrait figure, sometimes flanked by onlookers or a partner. Sometimes these portraits are of people in Garvey's life: Jackie worked with Garvey on his reading and writing in prison. He is most interested in these people's feelings: through colour and expression they communicate hurt, dejection, anger, calm, sometimes happiness: 'My work helps me release my emotions, it reflects the mood I am in, when I am happy my work is bright, colourful and smiley, when I am feeling melancholy my work is subdued and not so smiley, a lot more tears. I feel that art is a part of my life now. It keeps me sane, peaceful and calm.'

More recently his pictures have changed – they're less in your face and the expressions seem more contained, calmer, against a watery background.

Garvey has recently been released, and has gone back to Birmingham. He is hoping to go to art college soon.

above left: Garvey Thompson, *Rejected*, acrylic.
left: Garvey Thompson, *Jackie*, acrylic.
right: Garvey Thompson, *Closing Time*, acrylic.

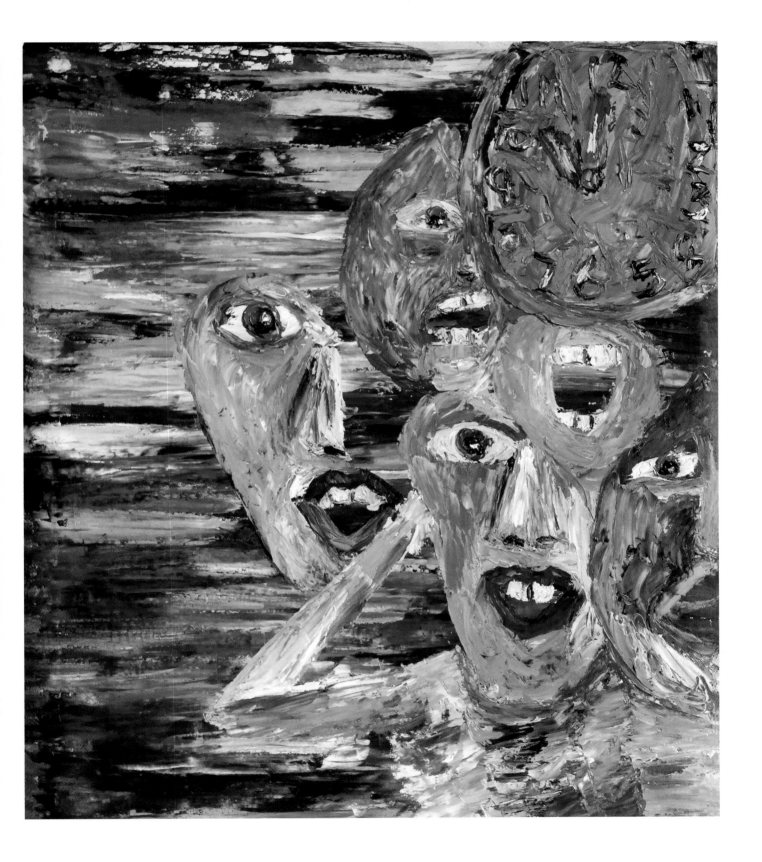

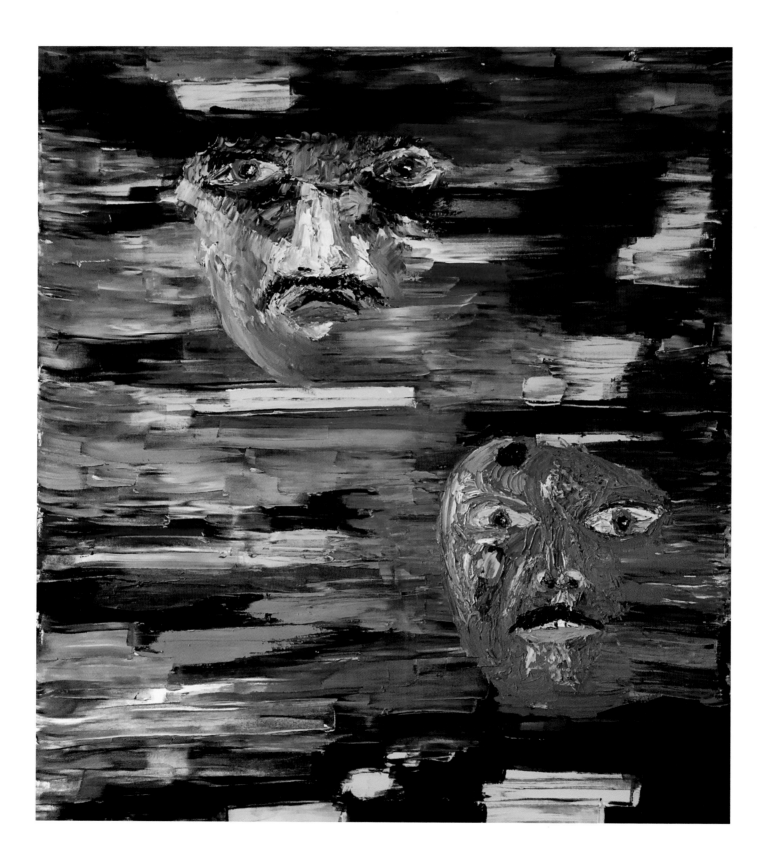

MATTHEW WILLIAMS

As far as custodial audiences are concerned Matt Williams is probably the best-known prison artist in the UK, on account of his monthly cartoon for *Inside Time*, the UK's national prison newspaper. This goes to every prison in the country, and each month 'It's A Con' hits the spot, dealing with issues immediately recognisable to anyone familiar with prison life. As a veteran lifer moving round the dispersal system[7] for more than 20 years, Matt Williams has developed an acerbic and satirical eye for detail and dialogue. Overcrowding, healthcare, the aging prison population, homophobia, mobile phones, prison food: each of these topics arouses much concern and debate, condensed and expressed in a three frame cartoon. He also illustrated Andy Thackwray's popular *Inside Time* serial 'This Way Up'. Matt's cartoons and illustration are only part of his creative output, which has included writing, painting, sculpture and mixed media as well as other graphic work. In 2001 when he moved to HMP Full Suttone wrote *The Tale of Time's Fool*. This is an autobiographical graphic novel illustrating the story of the 'shamed knight who could never forget his wrong'. Embarking on an Odyssean quest, he battles through the prison system in a series of quixotic and allegorical episodes, sustained by romantic love. This remains the artwork he is most pleased with.

Born in Birkenhead, he says his introduction to art was through a book at home on Salvador Dali: 'His creation of a completely believable, consistent other world – albeit a distorted and frightening one – impressed me greatly, and for a long time I considered such 'photo-realism' to be the bench-mark of artistic expression.'

Matt marks the start of his 'formal' art studies at HMP Long Lartin in 1992.

Later at HMP Whitemoor, art teacher Mike Randall encouraged me to develop a more personal painting style, teaching me the use of colour and composition. I'm currently studying 'Art of The 20th Century' with the Open University. I've considered studying an MA in art when I'm paroled, though such courses are very costly, and will depend on whether or not my criminal record would bar me from attending university.

Matt has seen significant changes over his years inside:

Previously dispersal prisons allowed all sorts of materials. So many things you used to be able to get, but can't now. Depending on the prison, there were local sources and approved suppliers whose mail catalogues you could order from, such as W. Hobby's Ltd.[8] It was recognised that cell hobbies kept inmates busy, and if you were on the privileged list – security category D – you were eligible for more stuff.

Going from Long Lartin to HMP Parkhurst Matt produced his homage to Salvador Dali, a collection of artwork entitled *The Passion of St. Matthew*. A

left: Garvey Thompson, *Out of the blue*, acrylic.

Matt Williams, *Its a con 1–6,* pen and ink.

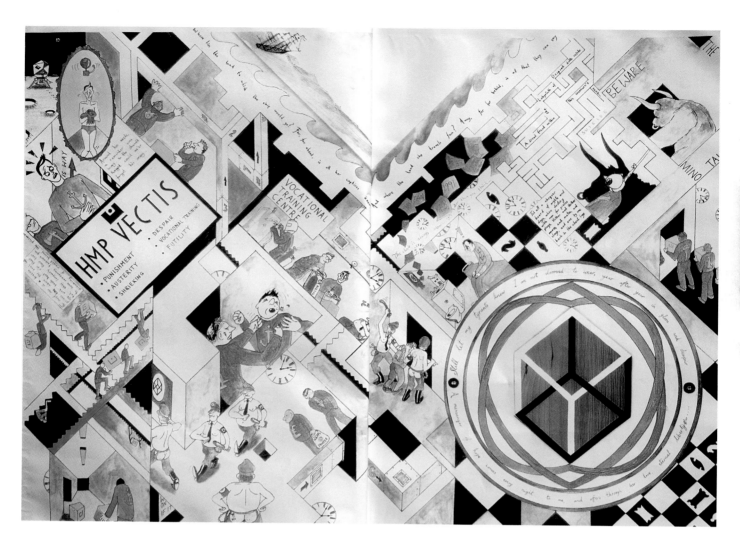

combination of paintings, sculpture and installation, this collection was, as its title suggests, also autobiographical, dealing with the artist's perceived martyrdom, including a surrealist-inspired attack on the Catholic Church. The work was to have been exhibited on the Isle of Wight, however Matt and two other prisoners succeeded in escaping from Parkhurst,[9] helped partly by a ladder he had made whilst making sculpture for *The Passion of St. Matthew*. He was recaptured before crossing to the mainland, and the exhibition eventually took place in The Spice Gallery in Birkenhead the following year after he had been transferred to HMP Whitemoor. It was reviewed by the Wirral *Globe* who noted its

'surreal content of sex and violence'. Writing about this work much later he recalled that

my wanting to delve into sex and violence was due to the prison environment I was (still am) in. Most prisoners are terrified of expressing any kind of 'violent' or taboo imagery, or unusual imagery in their paintings, fearful that the psychologist-security thought police will interpret them as proof of dangerousness. The consequence is that many prison art rooms, far from

above: Matt Williams, *HMP Vectis*, pen and wash.

opposite
above left: Matt Williams, *Bomb*, mixed media.
above right: Matt Williams, *Mantis Religiosa*, mixed media.
below: Matt Williams, *Inferno plan,* paper.

Slow burning delay fuse

CIRCLE I: The Gates of Hell
Abandon hope all ye who enter this place.
Strips of cut up appeal documents form the first level of Damnation;
beyond the failed appeal there is no more hope of merciful deliverance

CIRCLE II: The Wall of Fustration
Formed from pulped complaint forms this level is the concentration of years
of official lies, contradictions, refusals and denials.
However just or reasonable any complaint is,
it invariably results in denial or total unacknowledgement.

CIRCLE III: The Paper Maze
Dozens of application forms (for every concievable request)
notices, official posters, information leaflets etc. have been
pulped to form this level. Here, a Sinner can wander blind for years
until, inevitably, he reaches The Wall of Frustration.

CIRCLE IV: The Wall of Uniformity
Composed of prison issue kit eg. toothbrushes, razors,
clothing, hard toilet paper... this is a level where all individuality
is conspired against. The use of the same items in all establishments
enforces the notion of the death of the individual, and the damnation of
the soul to the region of no change.

CIRCLE V: The Waiting Room
The core, the center of most of the Sinner's life.
Composed of pulped personal letters, contents of ashtrays, pornography,
pieces of a cassette player, all these items are examples of the
meaningless occupations a Sinner must perform
to pass eternity. The sinner has created the centre of his own damnation.

CIRCLE VI: The Prisoner
A photograph taken from a news-paper
forms the center of all damnation— the self.
The Prisoner is the ultimate author of his own Damnation.

Foundation : Lid of prison issue urine container.

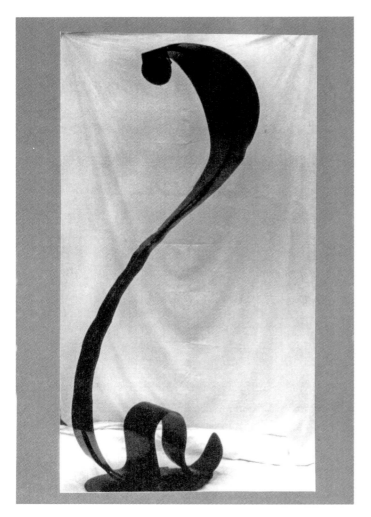

being places of inner expression and exploration, become 'approved' image-making-display centres, crammed with endless tedious still lives or hideous pastel portraits of animals and families. Most prisoners dare not delve any deeper, cowed by the terror of the 'miserable scribblers' in dingy offices. I've never been put off by such intimidation, and have let my creativity wander wherever it takes me.

Matt moved on from using such personal references in his work, doing portraits[10] and abstracted cityscapes along the way. When he wrote from HMP Dovegate he had developed some mixed media works, including the use of jewellery-related materials, and told me that 'my influences here include the Arts and Crafts, and individuals such as Kit Williams.'

He has had many battles with the system, at one point taking the Home Office to court about prisoners' rights to earn money from selling art in an attempt to recover payment for his play *Seascape* broadcast by Irish National Radio. He was unsuccessful, and feels bitter about writers such as Erwin James, Noel 'Razor' Smith and Lord Archer who he says have made regular money whilst inside.

above left: Matt Williams, *Serpent*, steel.
above: Matt Williams, *London*, acrylic. COURTESY OF THE KOESTLER TRUST.
right: Matt Williams, *Ochre Abstract*, acrylic.

OUTSIDE

Quite a few prisoners want to be artists once released, but having discovered a creative vocation whilst inside, where making art had become an important part of their lives, it has not been easy to keep their art going 'on the out'. Immediate priorities such as accommodation, finding work, looking after children and other family commitments take over. It's difficult then to find the time and place to do artwork.

Keeping the commitment and motivation going is hard enough for graduating art students, even with their final year professional development course at art college helping to prepare them for the world of the professional artist or designer. Unless they have been trained for the applied arts or creative industries job markets they will probably do other work alongside their art practice. Hopefully this will use their art skills, and many artists get to teach art, perhaps in a prison education department, or work in the community, 'social' or public arts sectors. Some – particularly those with a good head for business and publicity – make a living just from selling their art: useful qualities which are relatively rare in the artistic gene pool.

Some inmates with creative ambitions for release may well have these qualities, and have probably been encouraged by winning Koestler Awards. Many get advice from education department art tutors, who are usually artists themselves. From this informal information about buying material or equipment, art courses, exhibiting and selling work, and networking, they begin to get a realistic idea about what being an artist involves. Even though art is still largely seen as a softer option in prison education departments, some are responding to possible vocational and career pathways in art and design. At HMP Downview the Media Centre gives women accredited training in programme-making using the prison's TV system, and the art department has developed informal 'progression' links with Croydon College's art and design courses. The education department at HMP Gartree is running a BTEC in Art Enterprises, where students can do art-based business studies as well as a digital 'e-image' course.

It is harder for education departments in prisons with a high turnover to prepare ambitious art students for release, apart from informal advice, but most of those with more stable, longer-term populations could do more. The Koestler Trust's ex-offender artists' mentoring scheme, now in its second year, is trying to meet this need, and showing early signs of success. Open to just-released award winners, it links them with professional artist mentors who help them find their creative level, meeting up regularly over a year. Keeping your art going on release can take many forms: apart from continuing art education, it might include access to recreational classes, opportunities to meet

other artists, visits to exhibitions. For the more ambitious, help with developing and exhibiting their art work is needed.

Dean Stalham and Lucy Edkins have been ambitious and single-minded enough to keep their art going, both with some professional success. Writers as well as artists, each has more than one creative string to their bow.

LUCY EDKINS

Unlike most prison artists, prison didn't make Lucy Edkins an artist – in fact she had already studied art at college – but it certainly helped her become one, and a writer too. How did this happen? In the early 1990s, then a drug addict, Lucy served time first in Bullwood Hall and then Holloway, for supplying class A drugs. (She was arrested the same day Nelson Mandela was released from Robben Island prison.) This was a defining experience for her, because in prison she discovered who she really wanted to be. Whilst on remand at Bullwood Hall she got a Koestler Award for a ceramic head, and soon afterwards exhibited a self-portrait, *Reflections in a Small Mirror,* in the 1991 BP portrait awards exhibition at the National Portrait Gallery.

Despite these encouragements, it was several years before she felt confident enough to concentrate on her painting. At Bullwood Hall she heard that a BBC documentary was to be made at HMP Holloway. Having studied film at college she thought she might be able to get involved, and managed to get herself sentenced there. Once at Holloway she got a cleaning job to get red-band status, which allowed her to participate more directly in the project. There was some opposition to this from an education tutor who was eventually overruled. Ten years later Lucy was to return to the prison to do creative writing workshops as part of a programme organised by the National Theatre, and met this tutor again in the education department. She half-recognised Lucy, who had asked to use the staff toilets, but failed to match the ex-prisoner's face with that of the visiting writer.

Since release, she has returned to prison several times, not as an inmate, but with theatre groups such as Clean Break, as well as doing creative writing workshops with prisoners. For several years this seemed the best way to work with the social and political issues she cared about. Later she found work in the human rights

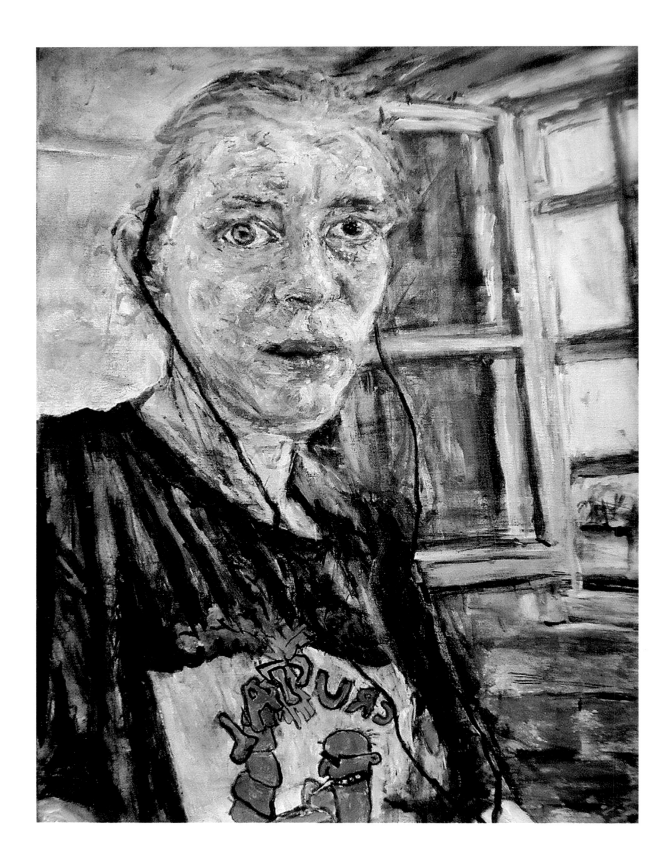

lawyer Gareth Pierce's office. At this time this law practice was defending three British internees at Guantanamo Bay prison – The Tipton Three – and the case inspired a series of graphic images by Lucy. These were based on photos of detainees in Guantanamo Bay and their own descriptions of conditions there. Her pictures were used to illustrate the *Guardian*'s report of The Tipton 3 in August 2004,[11] and attracted attention to Lucy's work. This in turn gave her the confidence to spend more time being an artist, and she began to have more successes. Next, Justice for Women commissioned a commemorative portrait of Emma Humphreys, the woman goaled indefinitely in 1985 for killing her partner after extreme physical, sexual and emotional abuse. Refused parole, she was released after 10 years of eventually successful attempts to clear her name by Justice for Women. She died three years later.[12] A further

left: Lucy Edkins, *Reflections in a small mirror*, acrylic.
above: Photo of Lucy Edkins.

commemorative portrait of feminist activist Andrea Dworkin followed, and her work had now found its natural voice, an expressive social realism, with subjects taking in social commentary and human injustice as well as portraits and landscapes, events from her own life. Lucy described her style like this: 'Painting like writing is a way of rediscovering the past – a way of telling a story about something I have half been given. It's a great way of rewriting my own history, a way of discovering your journey from the past into the future.'

In 2002 she visited HMP Belmarsh with a writing workshop from the National Theatre, and produced a series of etchings and other graphic work she called the Rendition series, exploring the psychological impact of detention without trial. Last year Lucy had several exhibitions of her paintings, drawings and prints. The largest, 'Portrait Dialogues', a collection of figurative paintings and drawings, was at the 'Our Space' gallery in the head office building of the mental health charity Together, on the edge of London's City area. It was an impressive exhibition – big compositions as well as small, cropped vignettes, all graphically descriptive portraits, mostly acrylics, in an energetic and colourful style. Also on show were her Belmarsh Rendition series. Lucy likes this kind of social context for her work, and has also exhibited her work in coffee bars, cafés, restaurants and recently the Union Theatre, where her play *Grooming and the Business Plan* was performed in a programme of one act plays by imprisoned and

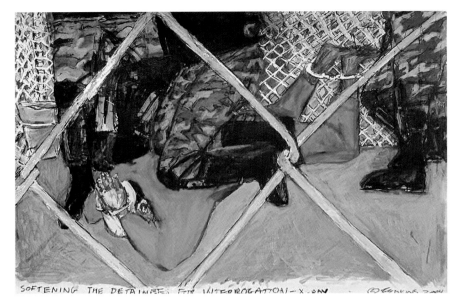

left: Lucy Edkins, *Softening the Detainees for Interrogation at Camp X-ray,* acrylic.
right: Lucy Edkins, *Emma Humphries,* acrylic.
below: Lucy Edkins, *Andrea Dworkin,* acrylic.

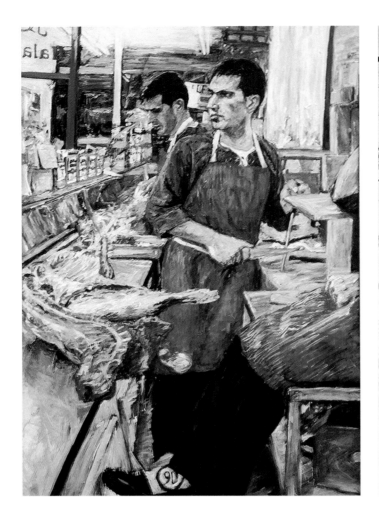

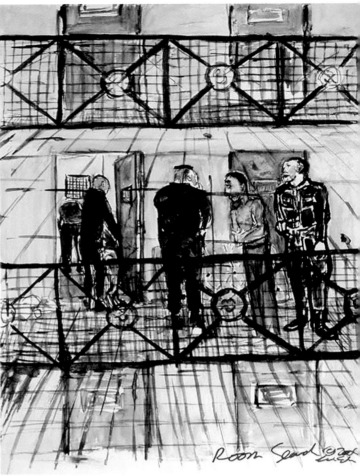

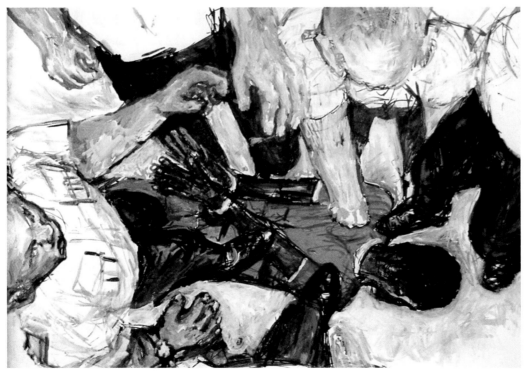

above, left: Lucy Edkins, *Abdullah*, acrylic.
above, right: Lucy Edkins, *Room spin,* mixed media.
left: Lucy Edkins, *Brute Focus,* mixed media.

opposite: Lucy Edkins, *Plaiting,* pencil.

released playwrights organised by Dean Stalham.

How has being in prison affected Lucy's prospects as an artist or writer? There is no doubt that it has given much of her work more credibility, though she thinks that she inherited her sense of social justice from her father's political beliefs, and said that even if she hadn't gone to prison she would still have been drawn to human rights issues. She continues to make work about issues in the criminal justice system, and continues to illustrate human rights publications, most recently raw, claustrophobic images for the report *Outsourcing Abuse* published by Medical Justice together with NCAD (National Coalition of Anti-Deportation Campaigns) in July 2008, which documents nearly 300 alleged assaults against UK asylum detainees. She illustrated the report *Dying on the inside: examining women's deaths in prisons* published by INQUEST last year with drawings she had made of fellow prisoners when in Holloway. Lucy is still writing, and is currently one of six ex-prisoner playwrights judging the annual national prison scriptwriting competition organised by the Royal Court Theatre with Synergy, a theatre company working in the criminal justice system.

Being in prison may have shaped Lucy's artistic career and perhaps helped it too, but in other parts of her life this is not seen as an asset. An experienced foster mother, she thinks she probably gets more 'challenging' placements as a result of her criminal record.

DEAN STALHAM

I first met Dean Stalham at HMP Wandsworth in 2004. He made a pop art style print of Mickey Mouse in my printmaking workshop there, rueful *homage* to the several Andy Warhols which had recently passed through his hands (these had been part of a collection of contemporary art he'd acquired through an antique fireplace deal). Dean has continued to work in the same graphic, appropriative spirit since then, often together with Liverpool artist Peter Cameron, who also became an artist whilst in prison. Recently they have collaborated in a series about Amy Winehouse, Dean collaging 'crack' paraphernalia around Cameron's strong pastel characterisations of the singer. (Dean bought the contents of a junkie's dustbin for £10.) Other contemporary subjects also provide fertile ground for their parodic twist: Glastonbury Music Festival, (where Dean met his partner and his daughter was conceived in 'hallucinatory circumstances') and the contemporary art scene (a down-and-out

screeving in front of the Tate Modern).

Dean was born in 1963 in Northwest London, the first of five children. Both parents came from local crime families: his first memory is of his mother pushing his Silver Cross pram up the front path, he lying in it across some large stolen item, while policemen squeezed past on their way into the house. Dean showed lots of early promise at primary school – captain of the football team, wrote plays, pulled girls – but things fell apart at secondary school where he felt cut down to size by vindictive teachers. He was humiliated by his art teacher in particular, and took revenge during the summer holidays by sneaking over his garden wall and cutting the heads off all the flowers. Dean himself detects an early trend here in acts of revenge against authority figures, paving the way for larger-scale crime.

At 15 his mother's cousin offered him a job in the building trade. This turned out to be sitting on a wall as lookout for his uncle's heroin dealing, £70 a week. Another uncle got him a proper job at the post office doing the night shift, but he wanted something more challenging. Taken on in a recording studio as general dogs-body, he asked for a more creative position with career opportunities. When told: 'We like you as you are', he started selling off equipment under the

opposite: Dean Stalham, *Amy Wraps* (with Peter Cameron), mixed media.

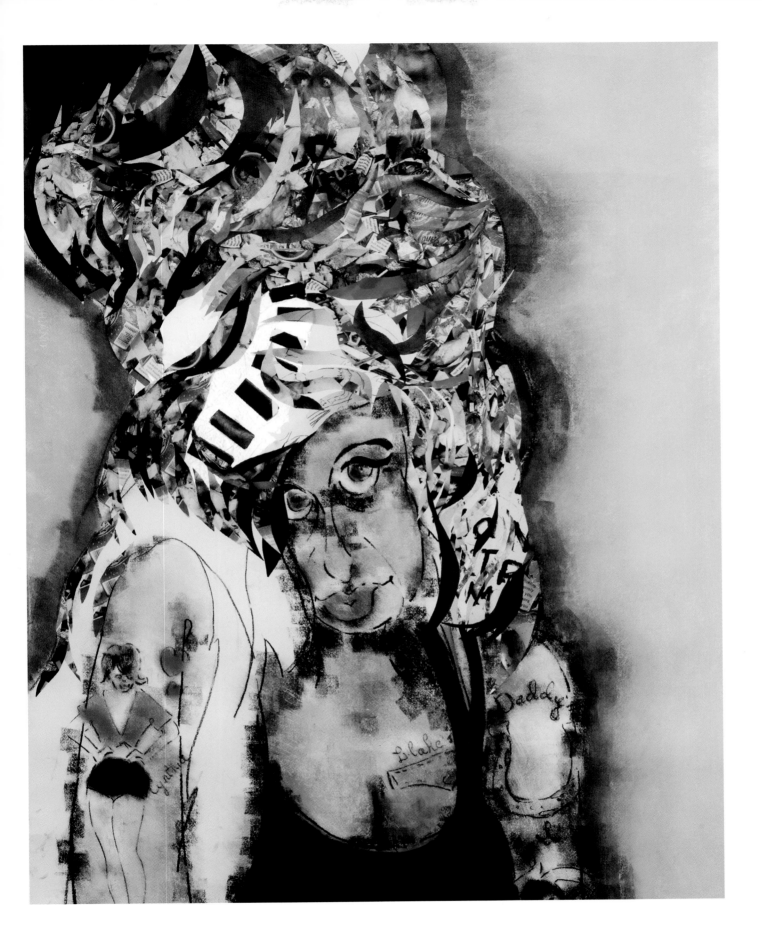

opposite: Dean Stalham, *Amy in the City* (with Peter Cameron), mixed media.
above: Dean Stalham, *Glasto for Baby* (with Peter Cameron), mixed media.

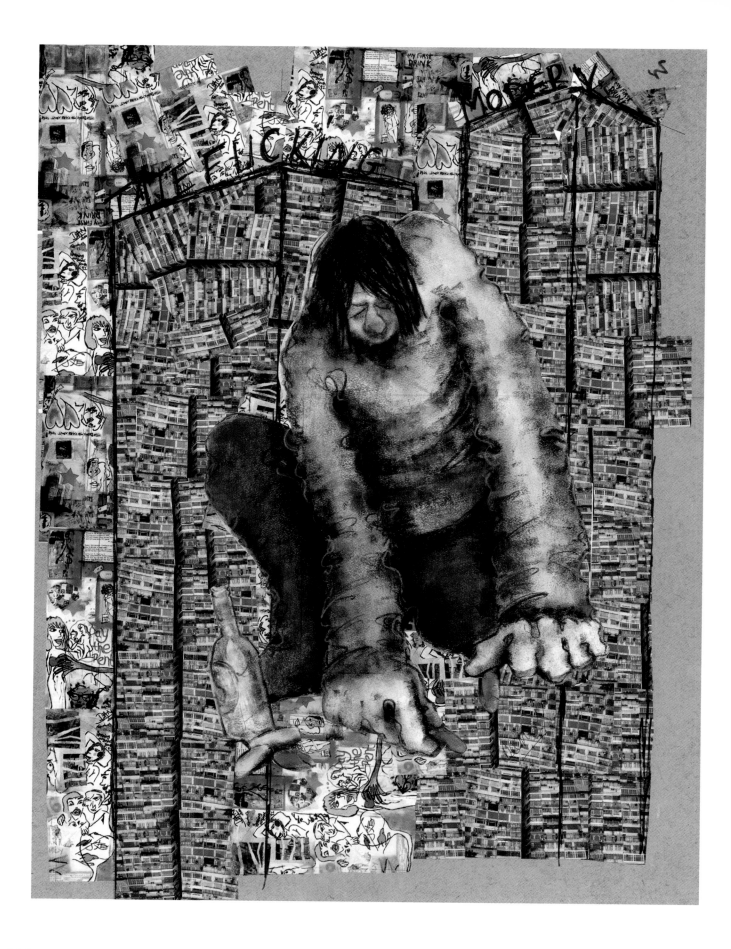

156

counter. Perhaps this was another act of frustration and revenge, but it was Dean's first real taste of easy profit, and when someone from the local post office came into the pub one night waving a handful of credit cards he got him over and did a deal, soon buying dozens a day. Dean gave up his day job to organise and run the biggest stolen

credit card ring in Europe at that time. He was eventually caught, serving most of his two-year sentence in open conditions at HMP Ford, outside Brighton. He claims to have made more money selling drugs to white-collar inmates than he ever had outside. Here his childhood love of art and drama was rekindled and encouraged by education tutors, though it took events during his second prison sentence at HMP Wandsworth ten years later to give him the confidence to realise and pursue his creative ambitions.

opposite: Dean Stalham, *Tate fucking Modern*, (with Peter Cameron), mixed media.
above: Dean Stalham, *Sporadicity,* mixed media.

Dean writes too, mostly plays.[13] He had done both at school, but what clinched it for him now was seeing a play put on by the Royal Court Theatre at the prison:

I talked to the director after and I said I could write a play and he said, 'Okay you write a scene at a time and send it to me'. I wrote a scene a month for three months. He told me to enter them for the Koestlers and I won. The Royal Court Theatre came in with some professional actors and they acted my play out. I was thinking: 'I can't go back now. This is it for me.' I haven't looked back.

And since his release in 2007 several of his plays have been staged in London, with critical success ('A brilliant new playwright ... like Pinter on speed' – *Time Out*, 2008). The first, *Sporadicity*, also featured his eponymous artwork. With his next play *Senti-Mental* he organised an exhibition of art by serving prisoners and ex-offender artists in the Union Theatre foyer and bar. 'That got interest of its own – so in future I want always to do that, to double up.'[14]

When he left prison Dean had contacted the Koestler Arts Centre, and after a spell as a volunteer was employed as an arts assistant there for two years. This provided financial stability whilst he developed his own artistic career, which

was supported by the Trust. But in his work processing submissions from across the criminal justice system Dean felt increasingly that he could no longer support the Trust's policy of exhibiting and selling artwork by artists from across the 'offending spectrum', knowing that this included artwork submitted anonymously by sex offenders. He believed they shouldn't be able to enjoy the benefits of exhibiting or selling their work, nor should they be allowed to remain anonymous, and left the Koestler Trust in 2009 following the publicity surrounding Colin Pitchfork's paper sculpture *Bringing the Music to Life*.[14]

Dean continues to paint and write plays, pursuing both careers energetically. Material for plays and pictures seems to come easily, often drawn from his earlier life of crime. This Hogarthian demimonde provides him with the moral subjects he likes, though their comic-strip comeuppances and contemporary 'progresses' have up until now – unlike Hogarth's – avoided prison: Dean is only too aware how difficult it is for ex-prisoners wanting to succeed in any creative career to 'cross over', leaving their prison background behind.

In 2009 he started a 'public interest' company called Art Saves Lives, promoting art, music and drama by marginalised artists, several of them ex-prisoners like himself.

NOTES

1 She believes these 'political' activities have singled her out for discrimination and punishment from authorities at previous prisons.

2 Clare is also a playwright, poet and author: poetry and fiction have been published in *Prison Writing* and *Women's Words*. One of her plays went to the Edinburgh Festival in 1997, and she has had others performed in different prisons. She has worked extensively with London Shakespeare Workout, writing sonnets and a dramatic treatment of *The House of Bernarda Alba* (entitled *Alba*) performed at HMP Send and at the Criterion Theatre in the West End

3 Clare's descriptions of her pictures were written for the Big Issues exhibition catalogue.

4 Whilst on remand he painted the prison chapel, commissioned by the Church of England chaplain. There is an excellent view of the chapel from the art room windows. The detail's there, but his heart wasn't in it.

5 Atlantis Art Materials, 7–9 Plumbers Row, London, E1 1EQ

6 Ongoing evaluation shows the programmes work best with low and moderate risk sex offenders and are least successful with those considered higher risk.

7 Following a number of well-publicised escapes from prisons in the 1960s, the dispersal system was established whereby Category A prisoners (those most dangerous and/or most likely to try to escape) were dispersed around the High Security prison estate. Other means of housing 'high risk' inmates are now deemed more effective.

8 For further information see http://www.hobby.uk.com.

9 This escape caused severe embarrassment to the Prison Service and led to the resignation of the Chief Executive Derek Lewis. This hasn't helped Matt's chance of parole.

10 In 2005 the Home Office bought Matt's portrait of hoarder Edmund Trebus as part of a purchase of anonymous Koestler Award winners, though Matt himself publicised the sale and his percentage of the price: £375. The Conservative MP Mike Penning was quoted as saying: 'These payouts for prisoners' artworks are an insult to the victims of crime – the money should be paid back to compensate for the huge cost of his escape and of investigating his crimes.'

11 This included extracts from *Detention in Afghanistan and Guantanamo*, published by lawyers of three British Muslim detainees who were eventually released after being held at Camp X-Ray military prison in Guantanamo Bay without charge for three years.

12 see http://www.emmahumphreys.org/

13 Other artists in this book – Matthew Williams and Lucy Edkins for example – also make art and write with equal facility.

14 All quotes are extracts from an interview with Dean Stalham published in issue 8 of *Not Shut Up* (June 2008), the creative writing magazine which publishes work by residents of London prisons (http://notshutup.org)

15 This issue is discussed at greater length in the introduction.

Further Resources

Books

Art behind barbed wire (*Exhibition catalogue, The Walker Art Gallery Liverpool, 2004*).

Blatter, B and Milton, S. *The Art of The Holocaust* (Pan Books, London 1982).

Boelen, L., *Art in Prison: Anonymous works of art by young detainees* (Neue Vossveld Prison, Vught, Netherlands, 1996). See also artinprisons.ne

Brandreth, G., *Created in Captivity* (Hodder and Stoughton, London 1972).

Bronson, C., *The Good Prison Guide* (John Blake Publishing, London 2007).

Brown, M., *Inside Art* (Waterside Press, Winchester 2002).

Foucault, M., *Discipline and punish: the birth of the prison* (trans. Sheridan, A., Penguin Books, London 1977).

Freeston. E. C., *Prisoner-of-war ship models 1775-1825* (Naval Institute Press, Annapolis, 1973).

James, E., *A life inside: a prisoner's notebook* (Atlantic Books, London 2003).

Johnston, N., *Forms of constraint: a history of prison architecture* (University of Illinois press, Champaign 2000).

Kornfeld, P., *Cellblock Visions* (Princeton University Press, Princeton 1997).

Living with the wire: internment in the Isle of Man during the two World Wars (Exhibition catalogue, Manx National Heritage, Manx 1994*).

Peaker, A. and Johnston, C., *Handbook for artists working in the criminal justice and crime prevention settings* (Anne Peaker Centre, Cantebury 2007).

Ramsbotham, D., *Prisongate* (The Free Press, London 2005).

Rhodes, C., *Outside art: spontaneous alternatives* (Thames and Hudson, London 2000).

Spoerri, E. and Baumann. D., *The Art of Adolph Wölfli* (American Folk Art Museum, New York 2003).

Toch. H., *Living in prison: the ecology of survival* (The American Psychological Association, Washington DC 1992).

Williams, S. 'Tookie', *Life in Prison* (Seastar Books, San Francisco 2001).

Magazines and newspapers

ConVerse – UK national prison newspaper www.spyholepress.com

Inside Time – UK national prison newspaper www.insidetime.org

Not Shut Up – periodic magazine featuring creative writing and art by people in prison, secure hospitals, immigration centres and other secure settings in the UK. www.notshutup.org

Women in Prison – periodic magazine of the charity which supports and campaigns for women offenders and ex-offenders, featuring art and creative writing by the same. www.womeninprison.org

Organisations

Art Behind Bars – Art-based community service programme for inmates in the Monroe County Detention Center, Florida, USA. *www.artbehindbars.org*

Art Without Bars – Belgian prison arts charity organising prison art and craft projects and exhibiting them. *artwithoutbars.be*

The Burnbake Trust – UK prison arts charity which provides modest funds for individual prison artists, as well as exhibiting and selling their work. *www.burnbaketrust.co.uk*

Fine Cell Work – Teaches needlework to men and women prisoners in UK prisons, exhibits and sells this work. *www.finecellwork.co.uk*

The Koestler Trust – UK prison arts charity which awards, exhibits and sells artworks by offenders, detainees and secure patients. It also runs a mentoring scheme for released prison artists. *www.koestlertrust.org.uk*

PAN (Prison Arts Network) – International information exchange for those working in different criminal justice systems. *www.panproject.org*

Prison Arts Foundation –Art projects in prisons in Northern Ireland. *www.prisonartsfoundation.co.uk*

Victim Support – The national charity for victims and witnesses of crime in England and Wales. *www.victimsupport.org.uk*